Sport in Art
from American Museums

Sport in Art
from American Museums

The Director's Choice

INAUGURAL EXHIBITION OF
THE NATIONAL ART MUSEUM OF SPORT

Foreword by George A. Plimpton
Introduction by J. Carter Brown

Edited by Reilly Rhodes

UNIVERSE, NEW YORK

front cover: Andy Warhol, *Athletes,* Wight
Art Gallery, UCLA (cat. nos. 57–66)

back cover: Paul Manship, *Wrestlers,*
Dayton Art Institute (cat. no. 33)

Book design by Christina Bliss

Exhibition Tour

The National Art Museum of Sport, Indianapolis
13 January–20 April 1991

Phoenix Art Museum, Phoenix
1 June –28 July 1991

The Corcoran Gallery of Art, Washington, D.C.
21 September–8 December 1991

IBM Gallery of Science and Art, New York
14 January –28 March 1992

Sport in Art from American Museums and its tour are made
possible by a grant from the IBM Corporation.

Published in the United States of America
in 1990
by Universe Publishing Inc.
381 Park Avenue South
New York, NY 10016

90 91 92 93 94 / 10 9 8 7 6 5 4 3 2 1

Printed in the United States of America

Library of Congress Catalog Card Number: 90–22559

ISBN: 0-87663-606-7

Contents

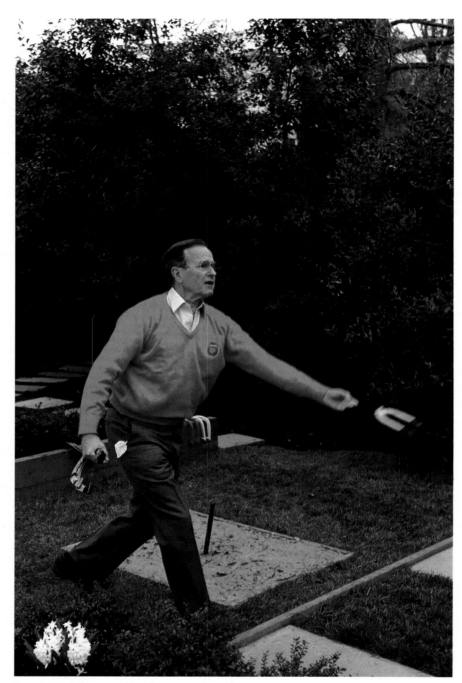

President George Bush

Foreword

As a sports journalist covering athletic events, I have always envied the professional photographers. With their long-snouted lenses and drive mechanisms in cameras constantly aimed at the action, there is little that can escape their scrutiny. When the game is over, their bags of film are hurried off to be processed so editors can choose from the results. Their job is done. The photographers are free to go out on the town, while the reporter—very often sitting in the empty bathtub of his hotel room so the sound of his portable typewriter won't disturb his neighbors—is still rapping away at his story well into the night.

And yet I suspect the photographer envies the painter or sculptor, examples of whose work comprise this exhibition and publication of *Sport in Art from American Museums*. This is not to suggest that the sports photographers do not produce extraordinarily evocative work, but they are invariably limited in their ability to record the "decisive instant" that illuminates, that tells us something more about the action observed than is at first apparent.

Ernest Hemingway, who said that his study of painting had much to do with the evolution of his style, had something to say about this: if the professional observer concentrated on moments of apparent inactivity (baseball teams coming on and off the field after an inning), an instant might be described that would stir the reader's subconscious and tell him something truer about baseball than the obvious drama of a home run. Painters and sculptors have far more opportunity to capture such instants than the photographer, since the images they begin to put on the canvas are created from the imagination. The photographer has only the barest opportunity to arrange the image seen in the camera's viewer. Nor can the sports photographer dictate the available lighting as can be done with a still life or a nude reclining on pillows. Perhaps more even than other photographers, the sports photographer must rely on luck.

The painter or sculptor has a significant advantage over the deadline-bound photographer or journalist in, for instance, trying to establish the scene and the mood depicted in Winslow Homer's *Guide Carrying A Deer*. Or imitating the unique style of Childe Hassam's *The Dune Hazard, No. 2*. Or matching the humor of Fletcher Martin's *The Glory* or the complexity of Jean Léon Gérôme's *Pollice Verso*, the savage wit of Paul Cadmus's *Aspects of Suburban Life: Golf* or the brooding serenity of Thomas Eakins's *Billy Smith*, the innovative brush strokes of Elaine de Kooning's *Scrimmage* or the unique perspective of Alex Colville's *Skater*.

Sport in Art from American Museums attests to the unique view the artist can bring to sport. I hope to have a catalogue to give a staff photographer the next time he's about to set out on the town after a night football game we're covering. "Hey!" I am going to say, "You think you got it right. Take a look at this."

George A. Plimpton

Preface

A quick glance at *Sport in Art from American Museums* reveals The National Art Museum of Sport's primary intention—to bring together important works of art, all from American museums, rather than simply to illustrate sport. With an emphasis on works of fine art that happen to be about sport, *Sport in Art from American Museums* was conceived as an ideal inaugural exhibition for the museum. The selection of artwork that has evolved is the result of a request to museum and gallery directors that they consider not only the theme of the exhibition, but also the purpose of a national museum devoted to sport in art. The participation of many distinguished directors and curators has provided this contemporary museum with an opportunity to bring together some of the most important works of sport-related art from some of the most prestigious museums in America, and to begin pursuing its mission of presenting exhibitions of high quality relating to sport.

The 1875 rediscovery of Olympia in southern Greece, site of the ancient games, caused worldwide excitement and interest in sports of all types. The enthusiasm generated by this event and the subsequent international effort to revive the games in 1896 mark the birth of modern sport. The exhibition focuses on the influence of the rediscovery and the enthusiasm it created, including the international endeavor of good will.

Most of the works presented here were created during the late nineteenth or early twentieth century. Early in this period, artists in America and abroad expressed the growing popularity of sport themes by painting scenes from the world around them—from Thomas Eakins's sailboats to George Bellows's boxing and Winslow Homer's hunting scenes. Some works were commissioned by wealthy amateurs (a word used both in art and sport) who appreciated fine paintings and sculpture; others represent the artists' interest in popular culture and the themes of modern life.

New technological innovations and inventions were bringing unparalleled prosperity to America. Fortunes were founded and, beginning with the upper class, Americans found time for leisure pursuits—yachting, croquet parties, lawn tennis, coaching, and outings to the beach or countryside. In New York, Central Park was developed; elsewhere, country clubs and cricket clubs opened, and people entertained with games and sporting activity in their homes and gardens. Cities like Boston, Pittsburgh, Chicago, and Los Angeles built large arenas to accommodate thousands of spectators at athletic events. Sport had become a broadly American pastime.

This publication and exhibition bear witness to the growth of that society. Although the works were chosen by independent directors, rather than by an individual curator with a single vision, they effectively let us see the emotional investment that sport and art both require and permit. We see the historical relationships between many of the works that have been juxtaposed with their counterparts—especially telling is Jean Léon Gérôme's *Pollice Verso (Thumbs Down)*, the moment of defeat, alongside Thomas Eakins's

Salutat, the victor gaining the approval of the crowd. In sculpture, Mahonri Mackintosh Young's boxing series of three bronzes has never before been illustrated together: we can here witness the animated action of *On the Button,* at the start of the fight; *Right to the Jaw,* in which one of the boxers is visibly shaken; and, finally, *The Knockdown* as the match is concluded.

The choice by many artists to depict competitive rather than recreational sport reflects their fascination with the visual and psychological dynamics of the activities they witnessed. It was not simply that Eakins and Bellows were sportsmen themselves, but rather that they delighted in the confrontation of the activity and the artistic opportunity for innovation and expression it afforded. The competitive aspect here is a celebration of the human figure in art and motion. *Sport in Art from American Museums* celebrates the essence of sports in art and clearly enlarges our visual appreciation and understanding of art—and sport.

Reilly Rhodes
Director
The National Art Museum of Sport
Indianapolis

Acknowledgments

An undertaking of the magnitude of this exhibition and catalogue has been the work of many dedicated and hard-working people. We are deeply grateful to President George Bush, honorary chairman of The National Art Museum of Sport, for his interest in the work of the museum. His rich athletic heritage and long association with Germain G. Glidden, chairman of the museum's Board of Trustees, provide the strength, support, and encouragement essential to the museum and its audience.

Together, Mr. Glidden and President James Q. Bensen gave the project their wholehearted support from its inception. Hawley T. Chester, Jr., vice president–finance, has provided invaluable assistance and counsel in our efforts to coordinate budget and revenue information during the course of raising funds for this project.

The National Art Museum of Sport wishes to express its deep appreciation to all the lenders for their generous cooperation in sharing their collections with us. We are indebted to numerous lenders throughout the country as well as to colleagues who were helpful in securing loans and assisting in the coordination of details that has made this exhibition possible. These include Jock Reynolds and Susan Faxon, Addison Gallery of American Art, Phillips Academy; Douglas G. Schultz and Laura Catalano, Albright-Knox Art Gallery; Dr. Lou Pyle and Tim Maslyn, Joe Brown Foundation; Stephen T. Bruni and Mary F. Holahan, Delaware Art Museum; Josie De Falla, Armand Labbe, and Teressa Ridgeway, Charles W. Bowers Museum; Louis A. Zona and Ed Amator, The Butler Institute of American Art; Merribell Parsons and E. Jane Connell, Columbus Museum of Art; David Scott and William B. Bodine, Jr., The Corcoran Gallery of Art; Bruce H. Evans and Dominique H. Vasseur, Dayton Art Institute; Samuel Sachs II and Nancy Rivard Shaw, The Detroit Institute of Arts; Martin H. Bush and Maria Ciski, Edwin A. Ulrich Museum of Art (Wichita State University); Leonard P. Sipiora, El Paso Museum of Art; Ronald A. Kuchta, Everson Museum of Art; Fred A. Myers and Anne Morand, Thomas Gilcrease Institute of American History and Art; Gudmund Vigtel, High Museum of Art; James T. Demetrion, Stephen E. Weil, and Phyllis Rosenzweig, Hirshhorn Museum and Sculpture Garden, Smithsonian Institution; Bret Waller and Ellen W. Lee, Indianapolis Museum of Art; Graham W. J. Beal, Joslyn Art Museum; Hugh M. Davies and Mary Johnson, La Jolla Museum of Contemporary Art; Earl A. Powell III, Los Angeles County Museum of Art; Philippe de Montebello and Lowery S. Sims, The Metropolitan Museum of Art; Russell Bowman, Jean Roberts, and Mariland Charles, Milwaukee Art Museum; Edith A. Tonelli, Wight Art Gallery, University of California at Los Angeles; E.A. Carmean, Jr., Modern Art Museum of Ft. Worth; Robert J. Koenig and Ronald Lomas, Montclair Art Museum; Paul D. Schweizer, Munson-Williams-Proctor Institute Museum of Art; René Taylor, Museo de Arte de Ponce; Alan Shestack, Museum of Fine Arts, Boston; Richard E. Oldenburg, The Museum of Modern Art; J. Carter Brown, National Gallery of Art;

Elizabeth Broun, National Museum of American Art, Smithsonian Institution; Alan Fern, National Portrait Gallery, Smithsonian Institution; Linda Bantel and Alesa Crane, The Pennsylvania Academy of the Fine Arts; Anne d'Harnoncourt and Irene Taurins, Philadelphia Museum of Art; Laughlin Phillips and Joseph Holback, The Phillips Collection; James K. Ballinger and Lynne Bowenkamp, Phoenix Art Museum; Barbara Shissler Nosanow, Martha R. Severens, and Barbara Redjinski, Portland Museum of Art, Maine; J. Richard Gruber, Wichita Art Museum; Steven L. Brezzo, San Diego Museum of Art; Thomas Krens, Solomon R. Guggenheim Museum; Robert A. Glascott, University of Pennsylvania; Andrew J. Kozar, University of Tennessee; Virgie D. Day, Brigham Young University Museum of Fine Arts; Margaret M. Mills and Larry Landon, American Academy and Institute of Arts and Letters; Jennifer Russell and Jane Rubin, Whitney Museum of American Art; Thomas N. Armstrong; Duncan Robinson, Yale Center for British Art; Dr. Mary Gardner Neill, Anthony Hirschel, Helen Cooper, and Susan Frankenbach, Yale University Art Gallery; Richard V. West and Nancy Doll, Santa Barbara Museum of Art; Michael Sanden and D. Scott Atkinson, Terra Museum of American Art; Robert R. Macdonald, Museum of the City of New York; Peter Fetchko, Peabody Museum of Salem; Holly Hotchner, The New-York Historical Society; Paul N. Perrot, William Rasmussen, and Carol Sawyer, Virginia Museum of Fine Arts.

We are grateful to the Phoenix Art Museum, The Corcoran Gallery of Art, and the IBM Gallery of Science and Art not only for their assistance in securing loans for the exhibition, but also for their collaboration with The National Art Museum of Sport as host museums for the exhibition's national tour.

Warmest gratitude must be extended to J. Carter Brown, director of the National Gallery of Art, for generously contributing the introduction to this publication and for taking the lead in establishing a standard of excellence for this project's "directors' choices." We wish to express our appreciation also to George Plimpton for both contributing to this catalogue with his foreword and being a friend and valued associate trustee of the museum.

Special thanks are due to D. Dodge Thompson, chief of exhibition programs at the National Gallery of Art, for his guidance and insight; and to Zachary P. Morfogen, chairman of Morfogen Associates, for his help in refining the concept of the exhibition and making it a reality. We are most grateful to both for giving their personal attention to the project and for generously sharing their knowledge with us.

Preparation of this exhibition and catalogue—indeed, any project of this scope—necessarily involves a large number of people and frequently requires modifications and changes in planning throughout the process. We wish to commend the following people, including former and current employees, for their enthusiastic cooperation amid other pressing deadlines. Special thanks are due to the director's assistant, Melissa Cooper, who helped coordinate

much of the detail work and took on scheduling responsibilities related to the organization of the exhibit; Teressa Ridgeway, registrar, who helped set up effective networking and professional registration systems for the museum; Ron Gibson, part-time registrar; Carol Fryer, administrative assistant to the director; and the entire staff of researchers, preparators and museum technicians.

We also wish to express our appreciation to Richard P. Berglund, director of cultural programs at IBM, and to the International Business Machines Corporation for making a difference in the arts in our society. Their support has played an important role in the public awareness and appreciation of important works of art depicting sport in American museum collections.

Lastly, we want to extend our deep appreciation to The National Art Museum of Sport Board of Trustees, Associate Trustees, and Advisors. These loyal and dedicated men and women and their families have helped make real the validity of a cultural life in our nation that celebrates a rich heritage in art and sport. It is to their example that we dedicate this publication.

R. R.

Introduction

The close bond between art and sport is an enduring one, and from it has come a rich bounty of memorable images. The word *sport* embraces a wide range of activities through which we leave behind the toils and troubles of daily life in search of pleasure, exercise, and spirited competition. Given such associations, and especially given the great diversity of human action and colorful physical settings involved, it is hardly surprising that sport should prove such an attractive subject for artists throughout history. Indeed, among our earliest forms of visual expression were hunting scenes painted on cave walls. Although these vivid documents of primal life are not sporting subjects in the true sense, the way they capture the energy and drama of the chase nevertheless allies them to the grand sporting art tradition that subsequently developed. And whether one thinks of the athletic contests portrayed in Greek vase painting and sculpture, the epic hunts that form the subjects of so many great medieval tapestries and manuscript pages, or the elegant horse-racing scenes of Edgar Degas, depicting sport has inspired artists across the millenia to some of their finest achievements. Even though the world's great art museums have not traditionally concentrated on acquiring and exhibiting sporting art, all would surely number among their greatest treasures at least a few with sporting subjects.

In America, a country celebrated for hard work and hard play, sporting art has had an especially vigorous history, and it is fitting that we should celebrate it with a national museum devoted to the subject. Many of our best painters—one thinks especially of Thomas Eakins, Winslow Homer, and George Bellows—were active sportsmen themselves, and numbered among their friends leading athletes, fishermen, and hunters. For them, as for many others, the multifaceted drama of sport was both challenge and inspiration, the generating force that led to unforgettable works. From the concentrated energy so monumentally expressed in Thomas Eakins's *Wrestlers* to the fashionable elegance of Homer's scenes of croquet matches, and from the exuberant animation of Seth Eastman's *Sioux Indians Playing Lacrosse* to the evanescent play of light and color across George Bellows's *Tennis Tournament,* the works in this exhibition and publication admirably document the richness of the conjunction between American sport and American art. They show us city and countryside, wilderness and water, athletes and spectators, hunters and the hunted, winners, losers, and those who simply play the game, offering eloquent evidence of the fascination sport has held for so many artists. And finally, as great works of art they equally remind us that bountiful human energy also finds an outlet in the creation of things of great beauty, moving content, and unending appeal.

J. Carter Brown
Director
National Gallery of Art
Washington, D.C.

Catalogue

1. **Alfred Boucher**
 French (1850–1934)
 Au But! (To the Goal), 1886
 Bronze (mounted on a waisted
 red marble socle), 13½ x 16¼ in.
 The National Art Museum of
 Sport, Indianapolis
 Purchase made possible through
 a special gift from Mr. Frank
 McKinney, Jr.

2. **Jean Léon Gérôme**
 French (1824–1904)
 Pollice Verso (Thumbs Down), 1872
 Oil on canvas, 39½ x 58¼ in.
 Phoenix Art Museum
 Museum purchase (68.52)

3. **Thomas Eakins**
 American (1844–1916)
 *Salutat (DEXTRA VICTRICE
 CONCLAMANTES SALVITAT)*, 1898
 Oil on canvas, 50 x 40 in.
 Addison Gallery of American Art,
 Phillips Academy, Andover, Mass.
 Gift of an anonymous donor
 (1928.20)

4. **Anonymous**
 Mayan; Yucatan, Mexico
 Polychrome cylinder vessel;
 late Classic Period, 550–950 A.D.
 Ceramic, 6¾ in. high x 6 in. diam.
 Charles W. Bowers Museum,
 Santa Ana, Calif.
 Foundation Acquisition Fund

5. **R. Tait McKenzie**
 American (1867–1938)
 The Sprinter, 1902
 Bronze, 8½ x 12 x 6 in.
 Delaware Art Museum, Wilmington
 The Samuel and Mary R. Bancroft
 Memorial

6. **George Stubbs**
 English (1724–1806)
 Rufus, ca. 1762–65
 Oil on canvas, 25⅝ x 30⅜ in.
 Indianapolis Museum of Art
 Gift of Mr. and Mrs. Eli Lilly

7. **Alvan Fisher**
 American (1792–1863)
 Eclipse, with Race Track, 1822–23
 Oil on canvas, 24 x 30 in.
 Munson-Williams-Proctor Institute
 Museum of Art, Utica, N.Y.
 Museum purchase (64.149)

8. **John Frederick Herring, Sr.**
 English (1795–1865)
 *''Memnon''
 with William Scott Up*, 1825
 Oil on canvas, 26½ x 33¼ in.
 Yale Center for British Art,
 New Haven, Conn.
 Paul Mellon Collection
 (B1981.25.753)

9. **William James Hubard**
 American (1807–1862)
 *The Angler (Portrait of
 Charles Lanman)*, 1846
 Oil on canvas, 15⅛ x 11⅞ in.
 High Museum of Art, Atlanta
 Lent by The West Foundation

10. **Seth Eastman**
 American (1808–1875)
 *Sioux Indians Playing
 Lacrosse*, 1848
 Watercolor on paper, 5½ x 8⅜ in.
 Signed l.r. margin of
 center, S.E. 1848
 Thomas Gilcrease Institute
 of American History and
 Art, Tulsa, Okla.

11. **James E. Buttersworth**
 American (1817–1894)
 *A Racing Yacht on the
 Great South Bay*
 Oil on canvas, 10 x 12 in.
 Virginia Museum of Fine
 Arts, Richmond
 Gift of Eugene B. Sydnor, Jr.
 (71.35)

12. **Fitz Hugh Lane**
 American (1804–1865)
 *The Yacht ''America'' Winning
 the International Race, 1851*
 Oil on canvas, 24½ x 38¼ in.
 Peabody Museum of Salem,
 Salem, Mass.

13. **Constant Troyon**
 French (1810–1865)
 Hound Pointing, 1860
 Oil on canvas, 64½ x 51⅜ in.
 Signed and dated at l.l.:
 C. Troyon 1860
 Museum of Fine Arts, Boston
 Gift of Mrs. Louis A. Frothingham
 (24.345)

14. **Winslow Homer**
 American (1874–1897)
 Croquet Match, 1867–69
 Oil on academy board,
 9¹³⁄₁₆ x 15⅝ in.
 Terra Museum of American
 Art, Chicago
 Daniel J. Terra Collection
 (32.1985)

15. **Thomas Eakins**
 American (1844–1916)
 *Sailboats Racing on
 the Delaware*, 1874
 Oil on canvas, 24 x 36 in.
 Philadelphia Museum of Art
 Gift of Mrs. Thomas Eakins and
 Miss Mary Adeline Williams

16. **William Morris Hunt**
 American (1824–1879)
 The Ball Players, ca. 1874
 Oil on canvas, 16 x 24 in.
 The Detroit Institute of Arts
 Gift of Mrs. John L. Gardner
 (07.12)

17. William Ranney
American (1813–1857)
Duck Shooting, 1850
Oil on canvas, 30¼ x 40⅝ in.
The Corcoran Gallery of Art,
Washington, D.C.
Gift of William Wilson Corcoran

18–21. Winslow Homer
American (1874–1897)

(18) *Trappers Resting,* 1874
Watercolor on paper, 9⅝ x
13¾ in.
(19) *Guide Carrying a Deer,* 1891
Watercolor on paper, 14 x 20 in
(20) *Pickerel Fishing,* 1892
Watercolor on paper, 10¾ x
19⅜ in.
(21) *Young Ducks,* 1897
Watercolor on paper, 13⅞ x
21 in.

Portland Museum of Art,
Portland, Maine
Bequest of Charles Shipman
Payson, 1988

22. John O'Brien Inman
American (1828–1896)
*Moonlight Skating—Central Park,
the Terrace and Lake,* 1878
Oil on canvas, 30 x 48 in.
Museum of the City of New York
Anonymous gift (49.415.2)

23. William Michael Harnett
American, born in Ireland
(1848–1892)
Merganser, 1883
Oil on canvas, 34⅛ x 20½ in.
San Diego Museum of Art
Gift of Gerald and Inez Grant
Parker Foundation
(SDMA no. 72:185)

24. John Rogers
American (1829–1904)
Football, 1891
Plaster, 16 in. high
Signed: John Rogers,
14 West 12th Street, NY;
inscribed in base: Football
The New-York Historical Society,
New York

25. Frederic Remington
American (1861–1909)
*Touchdown, Yale vs. Princeton,
Thanksgiving Day, November 27,
1890, Yale 32, Princeton 0*
Oil on canvas, 22 x 32⁹⁄₁₆ in.
Signed l.r.: Frederic Remington
Yale University Art Gallery,
New Haven, Conn.
Whitney Collections of Sporting
Art, given in memory of Harry
Payne Whitney, B.A. 1894, and
Payne Whitney, B.A. 1898, by
Francis P. Garvan, B.A. 1897,
M.A. (Hon.) 1922 (1932.264)

26. Robert William Vonnoh
American (1858–1933)
The Ring, 1892
Oil on canvas, 60½ x 72½ in.
Museo de Arte de Ponce (Luis
A. Ferre Foundation); Ponce, P.R.
Gift of the Banco de Ponce (68.0718)

27. Thomas Eakins
American (1844–1916)
Billy Smith, 1898
Oil on canvas, 21 x 17 in.
Wichita Art Museum, Wichita, Kans.
Roland P. Murdock Collection
(M16.40)

28. Thomas Eakins
American (1844–1916)
The Wrestlers, ca. 1899
Oil on canvas, 16¹⁄₁₆ x 20¹⁄₁₆ in.
Inscribed in another hand,
probably by Mrs. Eakins, l.r.: T. E.
Los Angeles County Museum of Art
Mr. and Mrs. William Preston
Harrison Collection (48.32.1)

29. Thomas Eakins
American (1844–1916)
The Wrestlers, 1899
Oil on canvas, 48⅜ x 60 in.
Signed and dated u.r.: Eakins/1899
Columbus Museum of Art,
Columbus, Ohio
Museum Purchase: Derby Fund,
1970 (70.38)

30. Henri Rousseau
French (1844–1916)
The Football Players, 1908
Oil on canvas, 39½ x 31⅝ in.
Solomon R. Guggenheim Museum,
New York

31. Charles Grafly
American (1862–1929)
The Oarsman, 1910
Bronze, 38¼ x 12 x 9½ in.
The Pennsylvania Academy of
the Fine Arts, Philadelphia
Gift of Dorothy Grafly

32. R. Tait McKenzie
American (1867–1938)
Onslaught, 1911
Bronze, 15 x 36 x 21 in.
The Lloyd P. Jones Gallery of the
Sculpture of R. Tait McKenzie,
University of Pennsylvania
Collection of Art, Philadelphia

33. Paul Manship
American (1885–1966)
Wrestlers, 1914
Bronze, 9¼ x 16¼ x 7½ in.
Dayton Art Institute, Dayton, Ohio
Bequest of the Honorable
Jefferson Patterson (79.71)

34. **Alexander Archipenko**
American, born in Russia
(1887–1964)
Boxers (La Lutte or the Fight), 1914
Bronze, 23½ x 18 in.
Milwaukee Art Museum
Purchase, Virginia Booth Vogel
Acquisition Fund

35. **George Bellows**
American (1882–1925)
In a Rowboat, 1916
Oil on canvas, 30½ x 44¼ in.
Montclair Art Museum,
Montclair, N.J.
Purchase made possible through
a special gift from Mr. and Mrs.
H. St. John Webb (64.37)

36. **George Bellows**
American (1882–1925)
Tennis Tournament, 1920
Oil on canvas, 59 x 66 in.
National Gallery of Art,
Washington, D.C.
Collection of Mr. and Mrs.
Paul Mellon (1983.1.5)

37. **Childe Hassam**
American (1859–1935)
The Dune Hazard, No. 2, 1922
Oil on canvas, 24 x 44 in.
American Academy and Institute
of Arts and Letters, New York
The Childe Hassam Fund Bequest

38. **R. Tait McKenzie**
American (1867–1938)
Pole Vaulter, 1923, cast ca. 1923–24
Bronze, 18 in. high
Marked: R. Tait McKenzie, Fecit 1923.
University of Tennessee, Knoxville

39. **George Bellows**
American (1882–1925)
Ringside Seats, 1924
Oil on canvas, 59¼ x 65⅛ in.
Signed in oil, l.r.: Geo. Bellows
Hirshhorn Museum and Sculpture
Garden, Smithsonian Institution,
Washington, D.C.
The Joseph H. Hirshhorn Bequest,
1981

40–42. **Mahonri Mackintosh Young**
American (1877–1957)

(40) *On the Button*, 1926–27
Bronze; 13⅞ in. high, base:
23¼ x 7⅜ in.
Signed on base: ''MAHONRI''
with copyright and thumb
print; foundry mark: ''ROMAN
BRONZE WORKS, N.Y.''
(41) *Right to the Jaw*, 1926–27
Bronze; 13⅞ in. high, base:
19⅛ x 7½ in.
Signed on base: ''MAHONRI
NO 12''; foundry mark:
''ROMAN BRONZE WORKS,
N.Y.''

(42) *The Knockdown*, 1927
Bronze; 23 in. high, base:
28⅜ x 12 in.
Signed on base: ''No. 1
MAHONRI'' with copyright;
foundry mark: ''CIRE/A.
VALSUANI/PERDUE''

Museum of Fine Arts, Brigham
Young University, Provo, Utah
Aquired, 1959, by Brigham Young
University through purchase
and gift.

43. **Paul Cadmus**
American (b. 1904)
Aspects of Suburban Life: Golf, 1936
Oil and tempera on fiberboard,
30¾ x 50 in.
National Museum of American
Art, Smithsonian Institution,
Washington, D.C.
Transfer from the U.S. Department
of State (1978.76.1)

44. **Richmond Barthé**
American (1901–1989)
Boxer, 1942
Bronze, 16 in. high
The Metropolitan Museum of Art,
New York
Rogers Fund, 1942

45. **Joe Brown**
American (1909–1985)
Boxers, 1943
Bronze, 24 in. high
Joe Brown Foundation,
Princeton, N.J.

46. **Milton Avery**
American (1893–1965)
Fencers, 1944
Oil on canvas, 48¼ x 32¼ in.
Santa Barbara Museum of Art
Given in Memory of Maximilian
von Romberg by Emily Hall,
Baroness von Romberg

47. **Andrew Wyeth**
American (b. 1917)
Trout Stream, 1948
Watercolor on rag paper, 22 x 30 in.
El Paso Museum of Art, El Paso, Tex.

48. **Fletcher Martin**
American (1904–1976)
The Glory, 1948
Oil on canvas, 36 x 48 in.
Edwin A. Ulrich Museum of Art,
Wichita State University,
Wichita, Kansas
Wichita State University
Endowment Association Art
Collection

49. **Oscar Howe**
American (1915–1983)
Sioux Boat Race, 1955
Tempera, 12⅞₁₆ x 22¾ in.
Joslyn Art Museum, Omaha, Nebr.
Museum purchase fund (1955.374)

50. Marjorie Phillips
American (1894–1985)
Night Baseball, 1951
Oil on canvas, 24⅛ x 36⅛ in.
The Phillips Collection,
Washington, D.C.

51. Nicholas de Staël
French, born in Russia
(1914–1955)
The Football Players, 1952
Oil on canvas, 32 x 25½ in.
Modern Art Museum of Fort Worth
Gift of Mr. and Mrs. William M.
Fuller

52. Elaine de Kooning
American (b. 1920)
Scrimmage, 1953
Oil on canvas, 24⅛ x 36 in.
Albright-Knox Art Gallery,
Buffalo, N.Y.
Gift of Mr. and Mrs. David K.
Anderson to The Martha Jackson
Collection (1974:8.16)

53. Alex Colville
Canadian (b. 1920)
Skater, 1964
Synthetic polymer paint on
composition board, 44½ x 27½ in.
The Museum of Modern Art,
New York
Gift of R. H. Donnelly Erdman
(by exchange)

54. Rhoda Sherbell
American (b. 1938)
Charles Dillon (Casey) Stengel,
cast in 1981 from a 1965 plaster
Polychromed bronze, 44 in. high
National Portrait Gallery,
Smithsonian Institution,
Washington, D.C.
Museum purchase

55. John De Andrea
American (b. 1941)
Boys Playing Soccer, 1971
Polyester and fiberglass resin with
polychrome in oil, 60 in. high
Everson Museum of Art,
Syracuse, N.Y.
Gift of Mrs. Robert C. Hosmer, 1972

56. Armand Arman
French (b. 1928)
Untitled, 1972–73
Plexiglas, resin, and football
helmets, 50 x 50 x 6 in.
La Jolla Museum of Contemporary
Art, La Jolla, Calif.
Gift of *Sports Illustrated*

57–66. Andy Warhol
American (1928–1987)
Athletes (series of ten), 1978

(57) *Muhammad Ali*
(58) *Chris Evert*
(59) *Bill Shoemaker*
(60) *Rod Gilbert*
(61) *Jack Nicklaus*
(62) *Pele*
(63) *Tom Seaver*
(64) *Kareem Abdul Jabar*
(65) *O. J. Simpson*
(66) *Dorothy Hamill*

Synthetic polymer and silkscreen
on canvas, each 40 x 40 in.
Wight Art Gallery, University
of California at Los Angeles
Gift of Frederick Weisman Company

67. Red Grooms
American (b. 1937)
Fran Tarkenton, 1979
Painted vinyl, aluminum armature,
with polyester stuffing, 96 x 56 in.
The Butler Institute of American
Art, Youngstown, Ohio

68. Rackstraw Downes
American, born in England (b. 1939)
*The Tennis Courts in Riverside
Park at 119th Street,* 1978–80
Oil on canvas, 18¾ x 46¼ in.
Whitney Museum of American
Art, New York
Purchase with funds from
the Louise and Bessie Adler
Foundation, Inc., Seymour
M. Klein, President (81.2)

1.

Alfred Boucher

French (1850–1934)
Au But! (To the Goal), 1886
Bronze (mounted on a waisted
red marble socle), 13½ x 16¼ in.
The National Art Museum of
Sport, Indianapolis
Purchase made possible through
a special gift from Mr. Frank
McKinney, Jr.

Alfred Boucher's sculptures received critical acclaim at the various salon expositions in Paris in the 1880s. The critic Jules Buisson remarked in the September 1881 issue of the *Gazette des Beaux Arts* that Boucher's work had great intensity for life, and a plaster group called *Filial Love* won the Prix de Salon.

In 1886 with his entry *Au But!* (to the goal), Boucher was awarded a first-class medal and praise from the critic Paul Leroi, in the July issue of *l'Art,* who said that Boucher's entry was ''one of the masterpieces which honors French art.'' The work dramatizes the interest in classical sports at that time, as a result of an important archaeological find in Greece—the rediscovery of Olympia and the uncovering of an arena where ancient games were conducted. (The discovery gave Baron Pierre de Coubertin, a French educator, the idea of organizing a modern, international Olympics. De Coubertin believed that athletics played an important part in forming a person's character, and also thought that international sports competition would promote world peace.) *Au But!* in fact contributed to the French enthusiasm for recreation of the Olympic Games. *Au But!* attracted the attention of the French people when it was entered for exhibit at the Academy and, in 1887, the French government commissioned a full-size bronze enlargement for the Luxembourg Gardens.

In a spiritual way we can all identify with the subject and its complexity—three runners racing to the finish. It is not only because of the sculptor's treatment of the human figures, but also because he combines attributes of physical beauty, mental alertness, strength, perseverance, and the striving toward excellence. Like the ancient classical games, it is a celebration of the human body in motion.

Reilly Rhodes
Director
The National Art Museum of Sport

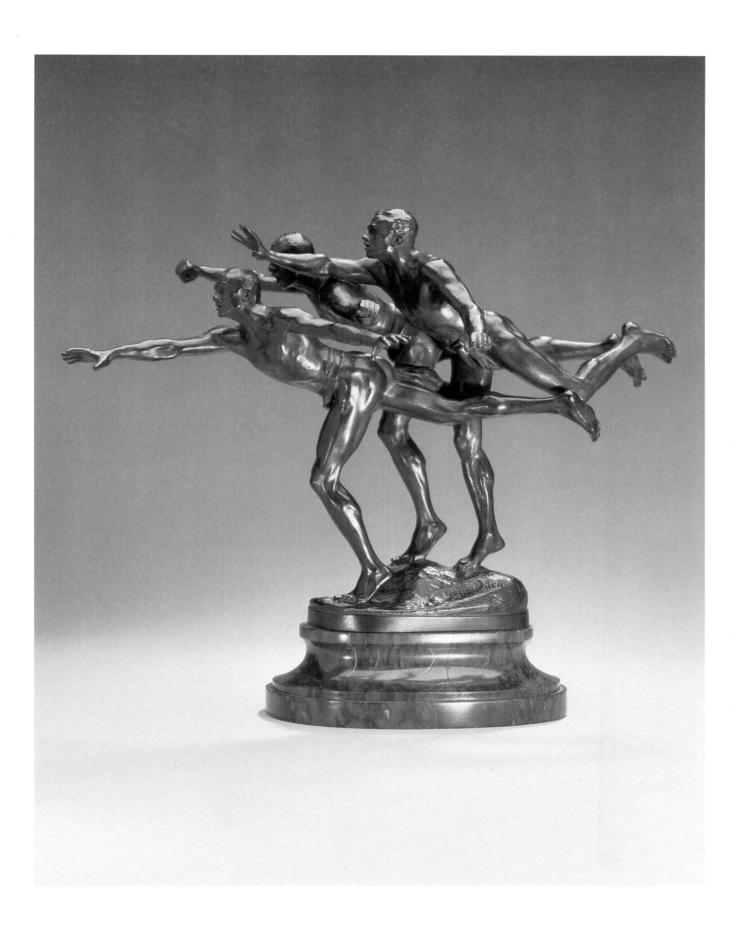

2.

Jean Léon Gérôme

French (1824–1904)
Pollice Verso (Thumbs Down), 1872
Oil on canvas, 39½ x 58¼ in.
Phoenix Art Museum
Museum purchase (68.52)

Jean Léon Gérôme was a tremendous force in nineteenth-century art. He was the leading exponent of the continuation of academic instruction, and fought the acceptance of the avant-garde movements burgeoning during the final decades of the century. Thomas Eakins, whom many scholars feel was America's greatest nineteenth-century artist, himself thought that Gérôme was the greatest artist of their age. Eakins studied with Gérôme in Paris from 1866 to 1870; Gérôme's influence on Eakins's art continued after the latter's return to America, and surfaced as well in Eakins's teaching at the Pennsylvania Academy of the Fine Arts. In addition to Eakins, over 150 aspiring American artists enrolled in Gérôme's atelier between the close of the Civil War and the turn of the century. What drew artists to the studio were Gérôme's technical abilities as a draftsman, his endless energy as a mentor, and his exacting methods of research and the resulting authenticity demonstrated in his great narrative paintings.

No work by Gérôme better demonstrates his approach than his masterwork *Pollice Verso (Thumbs Down)*, executed in 1874. He considered this painting to be one of his finest efforts. He had invested a great deal of time and money in researching and re-creating Roman gladiatorial contests, to the point of obtaining casts of antique armor and weapons. In addition, the painter created his own wax maquettes of the central figure group (enlarged four years later and cast in bronze for the Exposition Universelle) in order to capture their three-dimensionality accurately. Gérôme rendered with impeccable skill the human figures, the details of costume, and the particulars of surface texture and setting. The climax of a duel between a fallen net-thrower *(netarius)* and a victorious swordsman *(mirmillo)* is witnessed from the floor of the Colosseum. Stands rise above the gladiators and illusionistically curve into the background, indicating the oval shape of the arena. The emperor is seated in his box, and to his left are the vestal virgins enthusiastically gesturing "thumbs down." A golden light filters down through awnings over the Colosseum, not seen but suggested by the play of shadows over the spectators.

The painting's photographic accuracy and potential for melodramatic interpretation made it an exceptionally popular work in its day, and in ours. Engravings, chromolithographs, sculptural vignettes, even textiles were designed after it, and writers expounded on it. One detail in the painting caused considerable debate, however. The Roman call for death, *pollice verso*, literally means "turned thumb." No one in 1874 knew for certain whether that indicated a thumb turned up or down. A. T. Stewart, the first owner of *Pollice Verso* and one of America's great post–Civil War collectors, was a former classics teacher. He defended Gérôme's interpretation in a published pamphlet. Stewart's thesis, coupled with the painting's popularity, finally settled the issue in the public's mind. *Pollice verso* now means "thumbs down."

James K. Ballinger
Director
Phoenix Art Museum

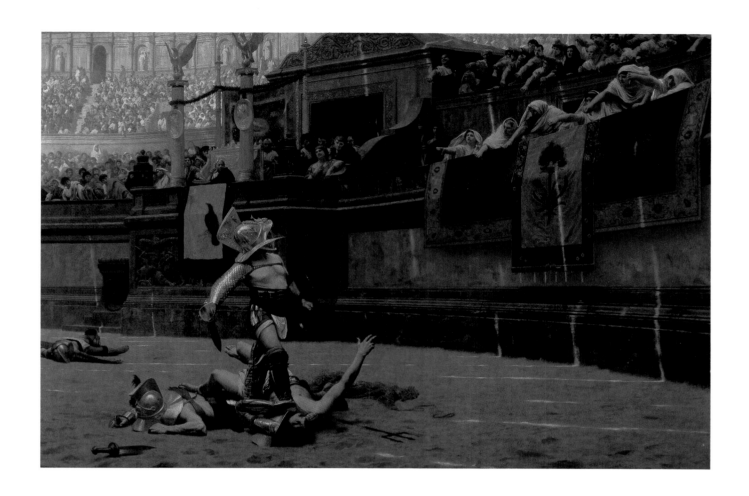

3.

Thomas Eakins

American (1844–1916)
*Salutat (DEXTRA VICTRICE
CONCLAMANTES SALVITAT)*, 1898
Oil on canvas, 50 x 40 in.
Addison Gallery of American Art,
Phillips Academy, Andover, Mass.
Gift of an anonymous donor
(1928.20)

Thomas Eakins's 1898 painting *Salutat* has commanded a position of honor in the collection of the Addison Gallery of American Art since its 1931 opening. Part of the remarkable collection of American paintings assembled by donor and patron Thomas Cochran, it is one of the three significant Eakins paintings purchased by Cochran for the museum at Phillips Academy.

Salutat is a celebration of Eakins's lifelong interest in human anatomy. From his earliest studies Eakins brought a scientific approach to his paintings, whether in the study of weather, the imposition of mathematical precision on problems of perspective, or the portrayal of the figure in his compositions. Eschewing the study of ancient casts and sculpture for the live model, Eakins devoted himself to analytical examination of the nude figure, in repose and in action, through the use of models and photography. His insistence on the use of nude models for both his men's and women's classes at the Pennsylvania Academy of the Fine Arts eventually forced his resignation as professor of drawing and painting in 1886. In the late 1880s, embittered by his loss of position, Eakins limited his work to portraits. The prizefighting series, of which *Salutat* is a part, comprises his first nude and nearly-nude paintings since *Arcadia* of 1883 and *Swimming Hole* of 1884–85.

Attending several prizefights with sculptor Samuel Murray in 1897 or 1898 inspired Eakins to paint the subjects of boxing and wrestling. According to Roland McKinney (*Thomas Eakins*, New York, 1942, p. 41), the sportswriter Clarence W. Cranmer and a friend obtained the services of the professional boxers who posed for the prizefighting series. Cranmer took Eakins to thousands of rounds of boxing before the artist could commence his work. Immortalized in *Salutat* are Eakins's fellow fightgoers Murray, Cranmer, and David Wilson Jordan, painter. The fighter is Billy Smith, who was featured in other prize-ring pictures of the same period, including *Taking the Count* and *Between Rounds*. A preliminary pencil sketch for *Salutat* is in the collection of the Hirshhorn Museum and Sculpture Garden, Washington, D.C., and an oil sketch belongs to the Carnegie Museum of Art, Pittsburgh.

The painting captures the fighter in full spotlight as he enters the ring. His arm is raised in acknowledgment of the crowd while the smoke-hazed audience applauds and waves from atop the stands. Unlike George Bellows's more savage visions of the fighter, Eakins's work is closer to classical images of the honored gladiator. The noble pose in *Salutat* is reminiscent of such works as Jean Léon Gérôme's *Pollice Verso (Thumbs Down)* (see cat. no. 2) which Eakins had seen during his Paris studies with the French painter at the Ecole des Beaux-Arts. *Salutat* retains its original frame which bears the carved Latin title, "DEXTRA VICTRICE CONCLAMANTES SALVTAT," under which the painting was exhibited at the 1904 World's Fair in St. Louis (no. 221).

Jock Reynolds
Director
Addison Gallery of American Art

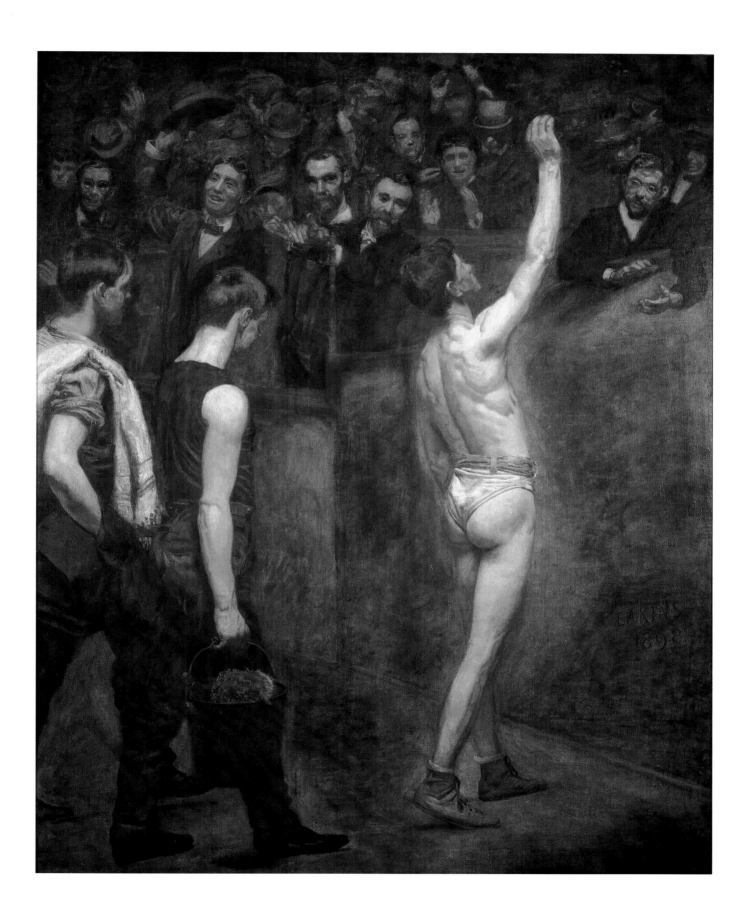

4.

Anonymous

Mayan; Yucatan, Mexico
Polychrome cylinder vessel;
late Classic Period, 550–950 A.D.
Ceramic, 6¾ in. high x 6 in. diam.
Charles W. Bowers Museum,
Santa Ana, Calif.
Foundation Acquisition Fund

Widely played over large areas of pre-Columbian Mesoamerica, the intriguing ritual ball game and its immense playing court have been a continual source of curiosity, intellectual speculation, and scholarly research for present-day archaeologists, anthropologists, and cosmologists, for nineteenth-century European traveler-scholars who were surprised by their jungle discoveries, and for sixteenth-century Spanish chroniclers.

The scene on this Mayan vessel may be a representation of a ball game taking place between mythical personages in the underworld. Such a game was described in the Popul Vuh, a Quiche Maya native narration, which was written down in the Quiche language employing Latin script during the sixteenth century. Three players, separated by glyph-like elements, are pictured on this vessel.

Pre-Columbian ball games were played primarily on I-shaped courts by opposing teams, using a hard rubber ball. Prior to the games, the players were arranged in various configurations on the stone steps and sloping stone walls which formed the boundaries of the courts. *Hachas*—stone sculptures in the form of human and zoomorphic heads—mounted on the court walls may have served as markers.

A range of murals, bas-reliefs, and figurines, as well as the drawings on this vase, depict ball players with yokes worn about the waist. Actual stone yokes have been found, typically carved from hard, green stone. In addition, players may have worn carved stone breastplates.

Actually many different games, ball games were played on several types of courts, according to differing sets of rules and with varying complex levels of religious and social significance. Cultural themes—carried out within the practices of the game—included duality, the cyclical nature of phenomena, and the relationship between sacrifice and the continuity of natural order. These themes have emerged in Mesoamerican art and iconography as well.

Ball courts have been found as far north as Flagstaff, Arizona. In addition to those found in Mexico and Central America, over one hundred have been found on Caribbean islands and the game is known to have been played by groups in northern South America. A contemporary version of the game, without the ball court, has recently been filmed in a village in northern Mexico.

Special research centers, exhibits, and seminars continue to be devoted to the representation and interpretation of this pre-Columbian game—an enduring symbol of a ceremonial sport that transcends the contemporary notions of popular heroism and entertainment to embody the entire world view and ritualistic mysteries of a civilization.

Josie De Falla
Director
Charles W. Bowers Museum

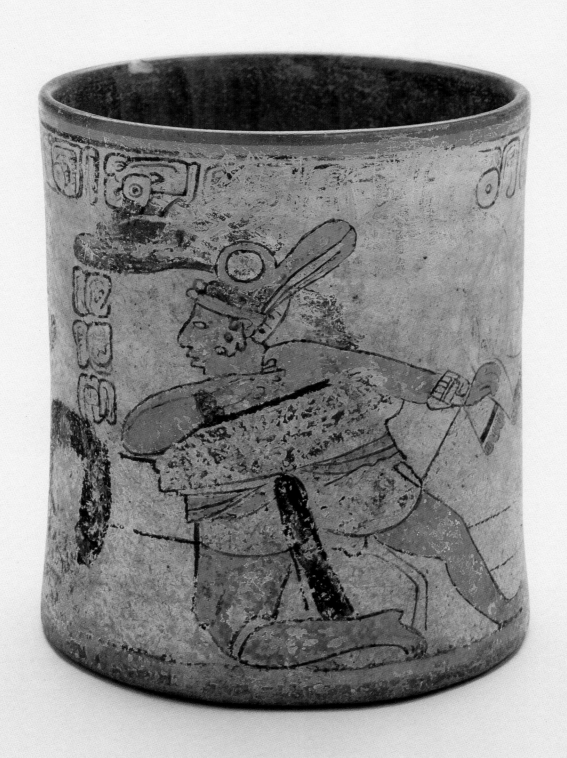

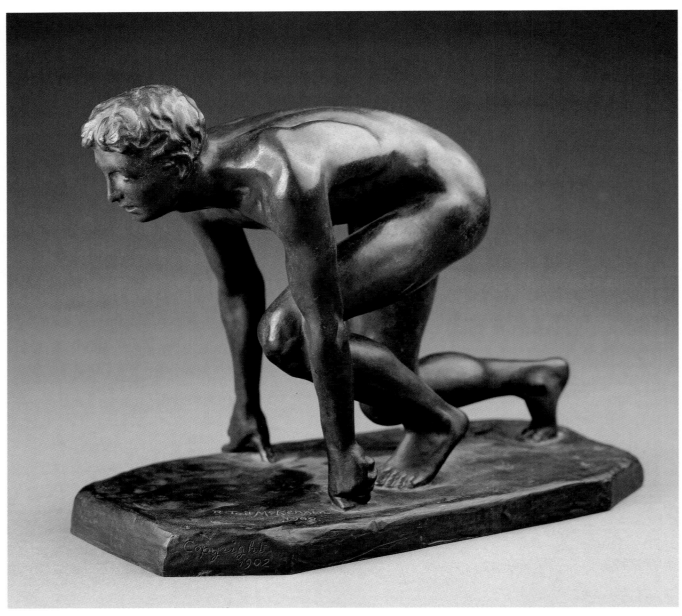

5.

R. Tait McKenzie

American (1867–1938)
The Sprinter, 1902
Bronze, 8½ x 12 x 6 in.
Delaware Art Museum, Wilmington
The Samuel and Mary R. Bancroft
Memorial

R. Tait McKenzie was America's foremost sculptor of athletes, as well as being a medical doctor and physical specialist. He sculpted both professional champions and amateur athletes, and was a supporter of the revival of the Olympic Games.

The crouching start for sprint racing became popular around the turn of the century. McKenzie uses this position to create a series of fluid outlines, counterbalanced by the tense energy of the muscles. *The Sprinter* makes evident the sculptor's thorough training in anatomy and his love of classical art.

Stephen T. Bruni
Director
Delaware Art Museum

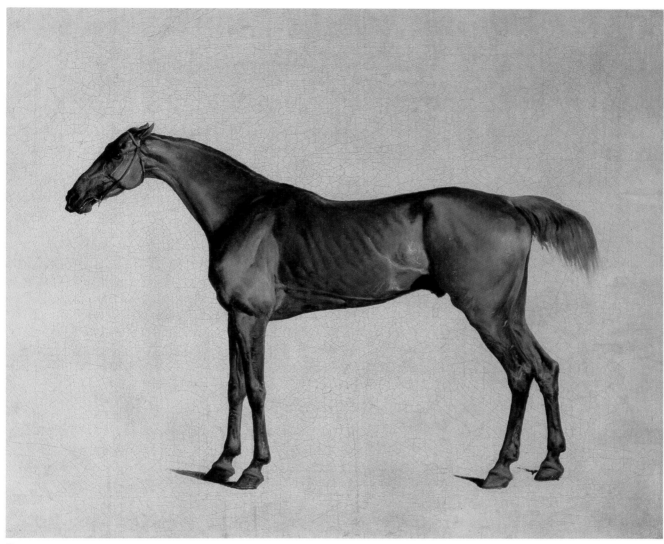

6.

George Stubbs

English (1724–1806)
Rufus, ca. 1762–65
Oil on canvas, 25⅜ x 30⅜ in.
Indianapolis Museum of Art
Gift of Mr. and Mrs. Eli Lilly

George Stubbs gives us here the archetypal racehorse. But for rudimentary shadows at the four hooves, this could be the heraldic device from a coat of arms or, perhaps closer to the mark, a page from Stubbs's own landmark folio, *Anatomy of a Horse* (1766). Stubbs's usual practice with such equine portraits was to paint the horse first and fit the landscape background in later. Occasionally he omitted the landscape entirely, either at the request of the owner or as part of his original conception. Many of Stubbs's equine portraits were commissioned by the horses' owners and reflect the enduring fascination of New and Old World gentry with horses and horse painting. In its objective accuracy, manifest here in the beautifully precise drawing and attention to the texture of the horse's coat, *Rufus* owes much to Stubbs's investigation of equine anatomy.

Bret Waller
Director
Indianapolis Museum of Art

7.

Alvan Fisher

American (1792–1863)
Eclipse, with Race Track, 1822–23
Oil on canvas, 24 x 30 in.
Munson-Williams-Proctor Institute
Museum of Art, Utica, N.Y.
Museum purchase (64.149)

Alvan Fisher combines portraiture and landscape in *Eclipse, with Race Track* to create a sporting picture that is one of his most successful images dealing with the American Turf. Paintings of celebrated thoroughbreds had been popular in England since the mid-eighteenth century, but were unknown in the United States before a group of racehorse portraits was commissioned in 1822 by Charles Henry Hall (1781–1852), the New York agriculturist and breeder. Fisher was the first American artist to paint domestic thoroughbreds for patrons such as Hall, who had become as fond of racing as their British counterparts. Though he portrayed Duroc, Sir Archy, Virginian, and Sir Charles, American Eclipse was unquestionably the most famous stallion ''excelling all the racers of the day, in the three great essentials of speed, stoutness, and lastingness, and ability to carry weight.''

Like the *portrait d'apparat*, in which a sitter's profession is suggested by both the accessories and surroundings, the subject of *Eclipse, with Race Track* is presented as an equine celebrity of muscular strength. Slightly angled from a profile view and facing right, American Eclipse stands brightly lit in the foreground, dominating the left side of the composition. The stance reveals his powerful front legs. Because the horizon is low, the contour of the thoroughbred's well-formed neck and back with plaited mane is prominently seen against a cloud-filled yet peaceful sky. He is firmly held by his owner, a literal reference to their relationship. Placed between Cornelius W. Van Ranst, who owned Eclipse during his most illustrious days, and the racehorse, Samuel Purdy is seen holding a saddle and wearing the vibrant red racing silks that are the owner's colors. He is the jockey who rode Eclipse to many victories. At the far right, a groom is folding the animal's blanket.

When Hall loaned his thoroughbred portraits by Fisher to the early exhibitions of the National Academy of Design, an important aspect of the artist's career was brought to public attention. In 1827, a critic in the weekly *New York Mirror* wrote: ''Mr. F. bids fair to become a first-rate animal painter.'' Although Fisher had introduced formal portraits of American racehorses to this country, his enthusiasm for native scenery caused him to forsake these sporting subjects in favor of landscape painting.

Paul D. Schweizer
Director
Munson-Williams-Proctor
Institute Museum of Art

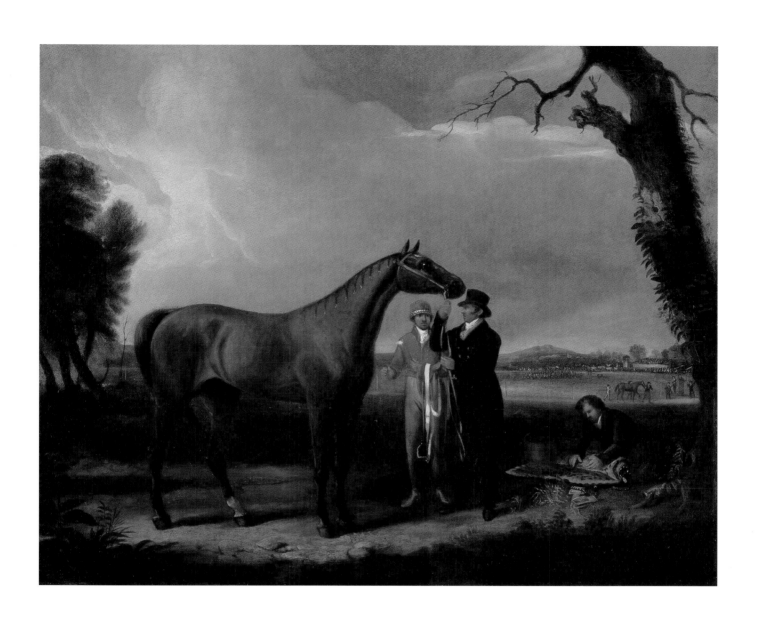

8.

John Frederick Herring, Sr.

English (1795–1865)
"Memnon"
with William Scott Up, 1825
Oil on canvas, 26½ x 33¼ in.
Yale Center for British Art,
New Haven, Conn.
Paul Mellon Collection
(B1981.25.753)

It is almost impossible to choose a single canvas from the comprehensive collections of British sporting art assembled by Paul Mellon. John Frederick Herring, Sr.'s portrait of Memnon and his jockey recommends itself, however, both as a self-evident masterpiece of animal painting and as a piece of interesting social commentary.

Herring painted two oils of Memnon, the three-year-old bay colt from Bishop Burton, near Beverley, Yorkshire, and winner of the St. Léger race in 1825, out of a record field of thirty horses. The first version, painted at Raby Castle and engraved in *The Annals of Sporting* (November 1825), shows horse and rider against an empty landscape. To this one, Herring added at a discreet distance the Doncaster grandstand, fashionable carriages, and spectators who witnessed Memnon's victory. These references to the growing popularity of horse racing in the nineteenth century are unmistakable: if the self-taught Herring looks back to the achievements in equine portraiture of George Stubbs and Benjamin Marshall, equally he anticipates the lively interest of the Victorians in the spectators as much as in the sport. It is no coincidence that Herring sketched for William Powell Firth the horses in his painting *Derby Day* in 1858.

Duncan Robinson
Director
Yale Center for British Art

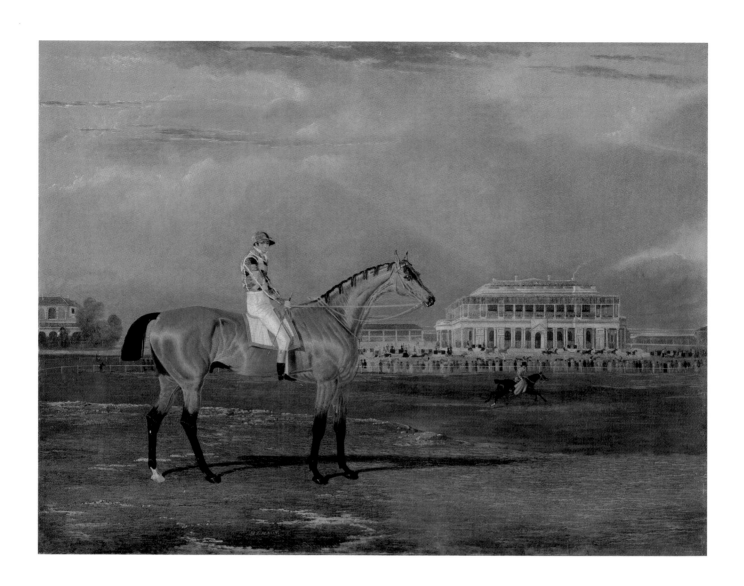

9.

William James Hubard

American (1807–1862)
*The Angler (Portrait of
Charles Lanman)*, 1846
Oil on canvas, 15⅛ x 11⅞ in.
High Museum of Art, Atlanta
Lent by The West Foundation

William Hubard painted this small but rather wonderful portrait. It seems well-suited for the inaugural exhibition and publication of The National Art Museum of Sport in that it embodies the spirit of the American artist as explorer and sportsman in the nineteenth century. The subject, Charles Lanman, was a competent landscape painter, a prolific writer, and an active outdoorsman. In 1845 he published a book called *Letters from a Landscape Painter*, which described his adventures in the beautiful backcountry of America and especially his friends Thomas Cole and William Sidney Mount.

Lanman was an avid angler and might well have commissioned his friend Hubard to paint his portrait as a fisherman, to serve as the basis for a frontispiece engraving in one of Lanman's books. The cabinet-size full-length portrait was Hubard's favorite format, and possibly Lanman chose Hubard knowing that the small painting would be ideal for translation into a line engraving. In fact, the firm G. & C. Cook did make an engraving after this portrait, intending it for the book *Adventures in the Wilds of the United States and the British American Provinces* (1856), but another portrait was substituted in the final publication. (According to a letter from Maurice Bloch to Donelson Hoopes, dated January 10, 1989, the published engraving was copied from a painting by Oskar Besseau.)

With pencil and fishing rod in hand, Lanman took many trips into the American wilderness, writing and sketching his impressions of the scenery and people he found from Washington to Maine. He was friend and confidant to many literary, political, and artistic figures of his day and can be counted among the true American Renaissance men of the nineteenth century.

Gudmund Vigtel
Director
High Museum of Art

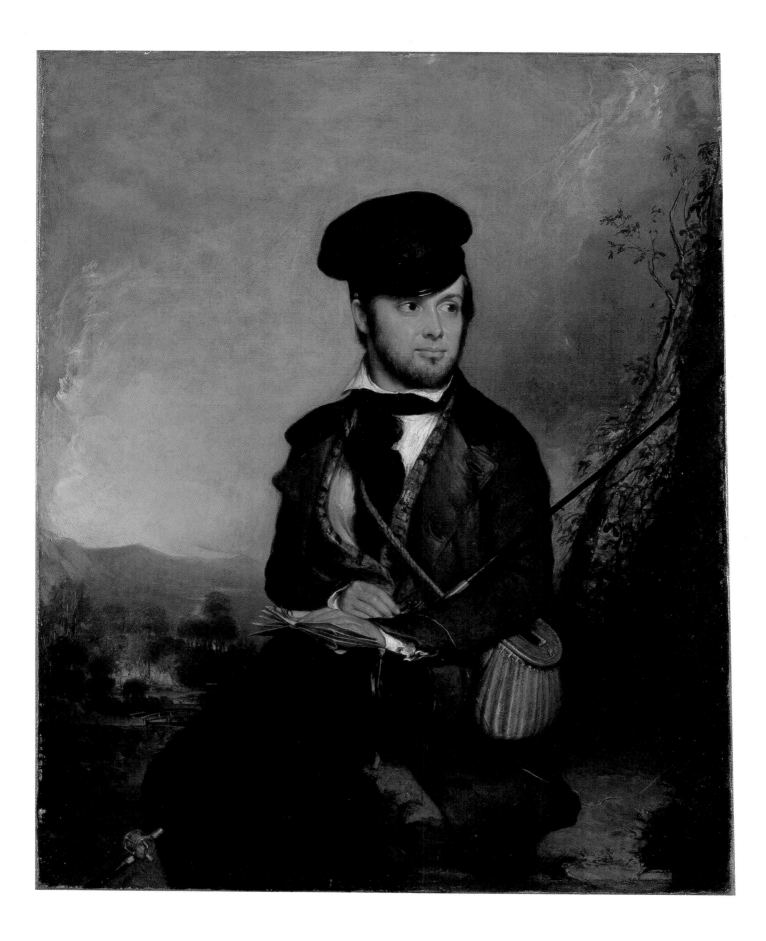

10.

Seth Eastman

American (1808–1875)
Sioux Indians Playing Lacrosse, 1848
Watercolor on paper, 5½ x 8⅜ in.
Signed l.r. margin of center, S.E. 1848
Thomas Gilcrease Institute of American History and Art, Tulsa, Okla.

To one's mental list of things native to America—such as field corn and the wild turkey—needs to be added the game of lacrosse. Early nineteenth-century written reports and some rare examples in the visual arts, such as this watercolor by Captain Seth Eastman, document that a game very similar to modern lacrosse was played by Indians in many tribes in eastern and central North America. The game (often called stickball in the southern plains) is similar to ice hockey in that a team using sticks attempts to advance an object beyond the opponent's goal. Direct use of the hands is disallowed; instead, a player catches the ''ball'' in a net at the end of his stick and advances it by running or throwing it to a teammate.

Seth Eastman's 1848 watercolor shows twenty players (the same as in modern lacrosse). Contemporary observers report, however, that Indian teams were often much larger, sometimes including whole clans or villages. The game—long and rough, even deadly, with sticks sometimes used as weapons—was usually played on ceremonial occasions, with strict observance of cleansing and dedication rituals. It was often also the basis for serious gambling.

Eastman, an Army officer, throughout his career managed to combine his military duties with his overarching desire to be an artist. As a student at West Point he received the then-standard drawing instruction intended to produce proficiency in drafting maps and plans. With the assistance of additional, privately financed art instruction, Eastman served as art instructor at West Point from 1833 to 1840, and even published a drawing manual during that time.

Captain Eastman had extensive opportunity to observe lacrosse played by Sioux Indians during his two tours of duty at Fort Snelling, Minnesota Territory. Stationed there for the second time from 1845–48, he learned to speak the Sioux language and became a reliable reporter on Indian life of the region. His knowledge and art ambition found an outlet in a six-volume Indian history published by the Bureau of Indian Affairs during the 1850s. The compiler of this publication, Henry Schoolcraft, brought Eastman to Washington, D.C., from 1848–56 as his assistant. Most of the chromolithographs of the first volume and the engravings of the next five are based on Eastman's images.

Sioux Indians Playing Lacrosse was used for the second volume of the Schoolcraft publication. The printed image was tricked out with clifflike hills, dramatic cloud effects, specific vegetation, and the suggestion of a soccer-like goal. The watercolor here, however, is a clearer example of Eastman's customary approach to many-figured compositions.

The figures are arrayed in the middle distance, in this case in active poses that vividly convey the melee of lacrosse action. Minimal treatment of landscape suggests a vast open land ever so lightly occupied by the Indians. The players in the engraving wore all-service tunics, while in the watercolor some wear only loincloths, a ritual custom described by observers.

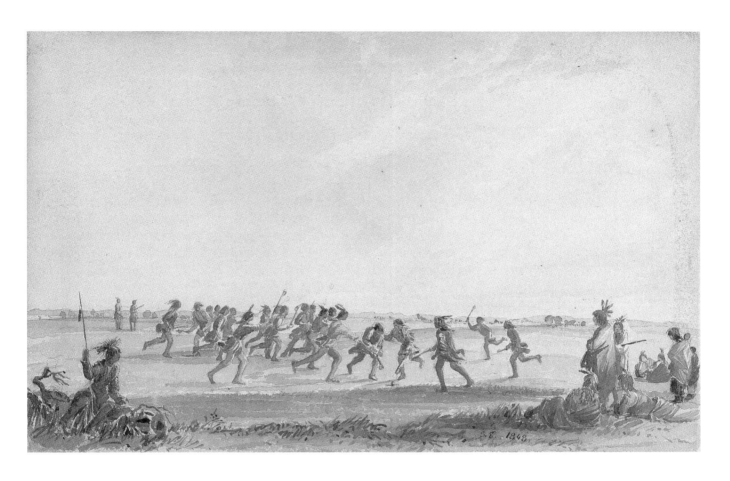

Finally—and most importantly for this sort of western art, which has been treated until recently more as ethnology than art—viewing Eastman's watercolor only as information would miss its context in the art of its time. Eastman typically makes use of *repoussoir* elements to frame and focus his composition. His art instruction at West Point and later, and his lifelong ambition to be an artist, prompted him to familiarize himself with art traditions whenever and wherever possible—reading on the western frontier and studying actual paintings when he was in Washington, Philadelphia, or New York.

The lacrosse spectator may have come most immediately from mid-continent America, but the art heritage demonstrated by pose and composition in this work reflect the classical figures of Greek and Roman art.

Fred A. Myers
Director
Thomas Gilcrease Institute
of American History and Art

11.

James E. Buttersworth

American (1817–1894)
*A Racing Yacht on the
Great South Bay*
Oil on canvas, 10 x 12 in.
Virginia Museum of Fine
Arts, Richmond
Gift of Eugene B. Sydnor, Jr.
(71.35)

Vast expanses, majestic skies, fearful storms, calm waters, billowing waves have been shown in countless paintings, engravings, drawings, and watercolors. Whether the principal subjects are the sea, coast, and surrounding atmosphere or rather the presence of man in such settings, there exists in many works an underlying sense that this is a milieu not to tamper with, one on which we depend for nourishment, transportation, and defense.

In the nineteenth century, another aspect came increasingly to the fore, that is, the sea now provided enjoyment. The striking shorelines of an earlier time increasingly gave place to inviting beaches, with a wandering couple walking along the shore, adventuresome bathers, or families happily vacationing. On the waves, pleasure boats and yachts joined the familiar and practical fishing boats, clipper ships, and men-of-war as worthy subjects. The contest between fragile shells and relentless waves continued, but another developed—the contest of will and skill among the crews of ships whose only purpose was pleasure and whose only aim was winning.

This theme is beautifully expressed in James Buttersworth's *A Racing Yacht on the Great South Bay*. The seas are relatively calm, the clouds suggest a vigorous breeze, and the majestic unfolding of the sails evokes the exhilaration of speed, the power of nature captured by the cloth, held taut by a crew intently concentrating on each movement, exploiting every subtle advantage provided by current and breeze.

Buttersworth is one of a relatively large number of artists who explored this subject with a sense of almost primitive innocence. This is the kind of picture that continues to move us to a sense of recognition, providing pleasure as well as wonder: a peaceful scene of innocent pursuit and demonstration of skill.

Paul N. Perrot
Director
Virginia Museum of Fine Arts

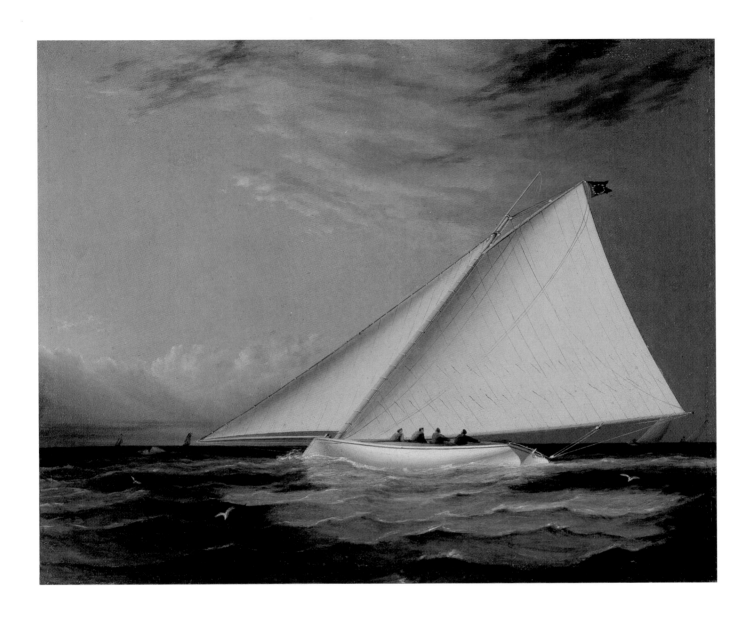

12.

Fitz Hugh Lane

American (1804–1865)
The Yacht "America" Winning the International Race, 1851
Oil on canvas, 24½ x 38¼ in.
Peabody Museum of Salem,
Salem, Mass.

One of the Peabody Museum's most popular oils is this painting by the Gloucester artist Fitz Hugh Lane, depicting the first international yacht race in 1851. The America's Cup prize was named for the schooner *America*, built in New York City in the same year for a group of members of the New York Yacht Club. The two-masted *America* was inspired by the fast, seaworthy American schooners then used by New York pilots. She was sailed to England where she competed for a trophy of the Royal Yacht Squadron called the Hundred-Guinea Cup, a race around the Isle of Wight. She defeated seventeen British yachts to capture the honors.

In 1857 the Hundred-Guinea Cup was deeded to the New York Yacht Club by the schooner's original owners, thereafter to be known as the America's Cup. It is interesting to note that the original sporting owners inserted a clause in the deed of gift to insure that only seaworthy yachts would compete, by requiring a challenger to cross the ocean under sail and "on her own bottom." This requirement, unfortunately, is no longer observed in this modern age of high technology navigation and legal maneuvering for the America's Cup.

During the Civil War the *America* was employed by the Confederates as a blockade runner, and then was captured and used as a Federal dispatch boat. The *America* subsequently was returned to use as a yacht, and presented in 1921 to the United States Naval Academy at Annapolis, Maryland, where she was finally broken up in 1946.

The commencement of international yacht competition in 1851 naturally engaged the attention of marine artists including James E. Buttersworth and Fitz Hugh Lane. In the event, however, Lane was not able to witness the Hundred-Guinea Competition and, in a departure from his normal working method, had to rely on the record of another artist. The painting by Lane of *The Yacht "America" Winning the International Race, 1851* was based on a sketch by the British marine artist, Oswald W. Brierly, which was engraved by another British marine specialist, Thomas Goldsworth Dutton, and published by R. A. Ackermann and Company in London immediately after the competition. While Lane was not able to take advantage of on-the-spot observation, nonetheless his tribute to the yacht *America* is a splendid, firmly-painted icon of sporting art.

Peter Fetchko
Director
Peabody Museum of Salem

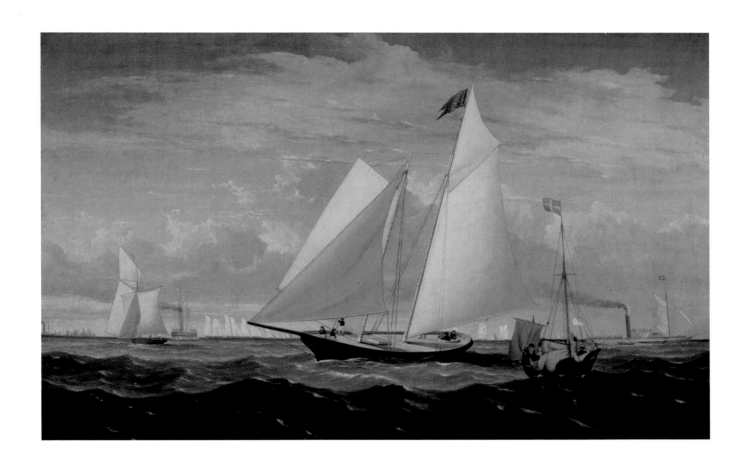

13.

Constant Troyon

French (1810–1865)
Hound Pointing, 1860
Oil on canvas, 64½ x 51⅜ in.
Signed and dated at l.l.:
C. Troyon 1860
Museum of Fine Arts, Boston
Gift of Mrs. Louis A. Frothingham
(24.345)

Constant Troyon's painting *Hound Pointing* (sometimes known by its French title *Le Chien d'Arrêt*) is one of the largest and most impressive works by this artist, who is known primarily as a painter of landscapes, often with grazing cows and sheep. In 1854, he made the first of many summer visits to the home of his friend, Mr. Loizel, in Touraine, France. There he found a kennel with hunting dogs, which he studied in detail. In this magnificent example, Troyon captures the dog at the moment it seems to catch the scent of its quarry in the air. The landscape with the gathering storm complements the animal's tense expectancy. While in the Prosper Crabbe collection in Paris, this picture caught the eye of poet-critic Baudelaire who praised it as an "excellent specimen."

Alan Shestack
Director
Museum of Fine Arts, Boston

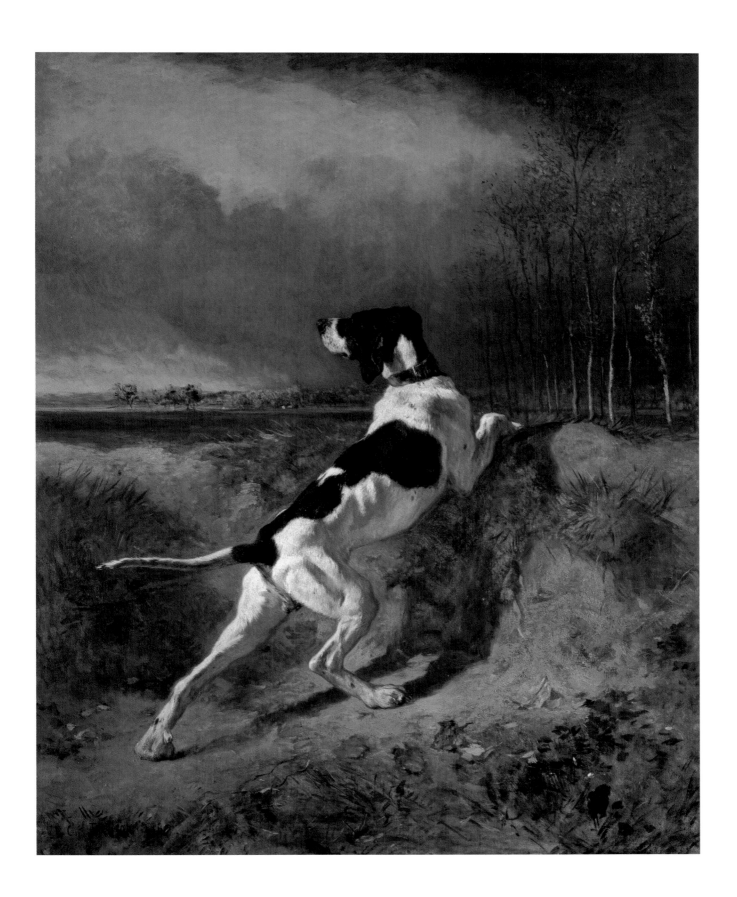

14.

Winslow Homer

American (1874–1897)
Croquet Match, 1867–69
Oil on academy board,
9¹³⁄₁₆ x 15⅝ in.
Terra Museum of American
Art, Chicago
Daniel J. Terra Collection
(32.1985)

Croquet, or "crooky," as the Irish originally called the game, was introduced to the United States from England in the mid-nineteenth century. It was the first sport to allow women to participate in physical activity while in the company of gentlemen. Like many fads, croquet started as an entertainment for the wealthy. The game received a great deal of attention among the privileged classes and was associated with many social gatherings organized by women. Croquet parties were very popular and expensive affairs, involving as many as one hundred guests.

During the 1860s, Winslow Homer produced a series of works related to the game of croquet. Five oil paintings, two chalk drawings, and a pair of wood engravings survive. Homer's *Croquet Match* in the Terra Museum collection is the only painting with an architectural setting and the only one that includes a second sport—badminton.

In the images Homer created, it is clear that he possessed a knowledge of the rules and familiarity with conventions of the game. They also show his interest in popular culture and modern life, a theme which was just beginning to be explored in Homer's time by American and European fine artists.

The asymmetric arrangement of forms, relatively unmodulated vivid colors, and treatment of the figures with strong silhouettes suggest Homer's acquaintance with Japanese woodblock prints, an important new stimulus in the 1860s. Homer was the first major fine artist to depict the game of croquet. Others followed, including superb examples by Edouard Manet in 1873 and James Jacques Joseph Tissot in 1878.

Harold P. O'Connell, Jr.
Director
Terra Museum of American Art

15.

Thomas Eakins

American (1844–1916)
*Sailboats Racing on
the Delaware,* 1874
Oil on canvas, 24 x 36 in.
Philadelphia Museum of Art
Gift of Mrs. Thomas Eakins and
Miss Mary Adeline Williams

Well over a century after Thomas Eakins painted *Sailboats Racing on the Delaware,* it remains one of his most immediately satisfying and serene works, full of the joy of brisk action in the open air. Yet it is a composition in which the artist's careful control and positioning of each element belies its air of a typical river scene, casually glimpsed. In his handbook *The Thomas Eakins Collection,* published by the Philadelphia Museum of Art in 1978 (pp. 57–58), Theodor Siegl gives an account of the picture and its context:

> Eakins was a rugged outdoorsman, with a passion especially for the water. He probably owned a sailboat, as Goodrich reports, . . . and on Sunday mornings he was frequently to be found sailing on the Delaware River.
>
> The view in *Sailboats Racing* appears to be from the Pennsylvania side of the Delaware, just below the city of Philadelphia, looking toward the New Jersey shore. A large number of sailboats are engaged in a race, which seems to turn at a point near the left side of the painting. In the distance is a steamer, presumably carrying onlookers and perhaps the judges. But the main interest of the painting is centered on the two boats in the foreground and their occupants, rendered in clearly distinguishable detail, who were undoubtedly friends of the artist although their identity is no longer known.
>
> Of all Eakins's paintings in the Museum's collection, *Sailboats Racing* recalls most strongly the painting and compositional techniques of his Parisian teacher Jean-Léon Gérôme. The precise balance of design in the painting and the meticulous, hard detail of the foreground figures, equally focused in the center of the composition and in the boat at right, are characteristics of Gérôme's own work. A few years hence, Eakins would decide that only in the focal point of a composition could the eye perceive as much detail, and thus, in later paintings, he would restrict the greatest detail to the area of the focal point. . . . Here, however, he still followed Gérôme's method.
>
> Eakins admired Gérôme, and throughout his own life never failed to credit the artist for having been his teacher. In 1873, three years after his return to America, Eakins sent a watercolor of a rower to Gérôme for criticism, and he followed up the next year with a second watercolor of the same subject to show how his work reflected the criticism he had received from Gérôme. In 1874, he also sent two oils to Gérôme, and in 1875, sent an additional four oils, for criticism and for exhibition in France.

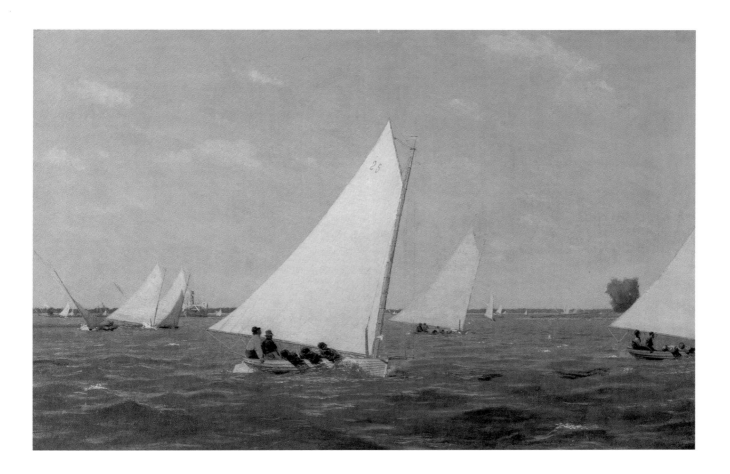

Siegl goes on to recount the evidence which makes it likely that *Sailboats Racing* was one of four ''oils'' sent to Gérôme in 1875, and surmises that it was the ''big one'' in which Gérôme criticized the water as ''painted like the wall,'' as Eakins describes his teacher's reaction in a letter to Earl Shinn of April 13, 1875. If indeed this is the painting with which Gérôme found fault, his complaint seems oddly off the mark today. The wind that sets the boats scudding along the brown waves seems to freshen as we watch, and the sunlight strikes the sails at an angle through a faint haze, as characteristic of this reach of the Delaware today as it was then.

Anne d'Harnoncourt
The George D. Widener Director
Philadelphia Museum of Art

16.

William Morris Hunt

American (1824–1879)
The Ball Players, ca. 1874
Oil on canvas, 16 x 24 in.
The Detroit Institute of Arts
Gift of Mrs. John L. Gardner
(07.12)

Painted about 1874, this marvelous work by William Morris Hunt illustrates the earliest images of America's national game. Hunt, a great teacher as well as a great painter, practiced his art in Boston and surely this scene took place in that vicinity. It ably demonstrates Hunt's interest in ambiguous space and the unsettling, hieratic scaling of the players is as much an artistic device as it is an illustration that this is a sport for all ages.

The rather ominous ''umpire'' looms in the foreground as a father figure to the diminutive and sketchy ''pitcher'' while the rest of the team, if there ever was one, vanishes altogether. The only important element is the contest between the batter and the ball on this quiet afternoon.

An intriguing dimension of the painting's history is that it was a gift from ''Mrs. Jack,'' as Mrs. John L. Gardner was known in art circles. Her collection, now permanently housed in the Isabella Stewart Gardner Museum in Boston, is internationally noted for its works by such heroes of William Morris Hunt as Velázquez, Tintoretto, Veronese, and Titian.

Samuel Sachs II
Director
The Detroit Institute of Arts

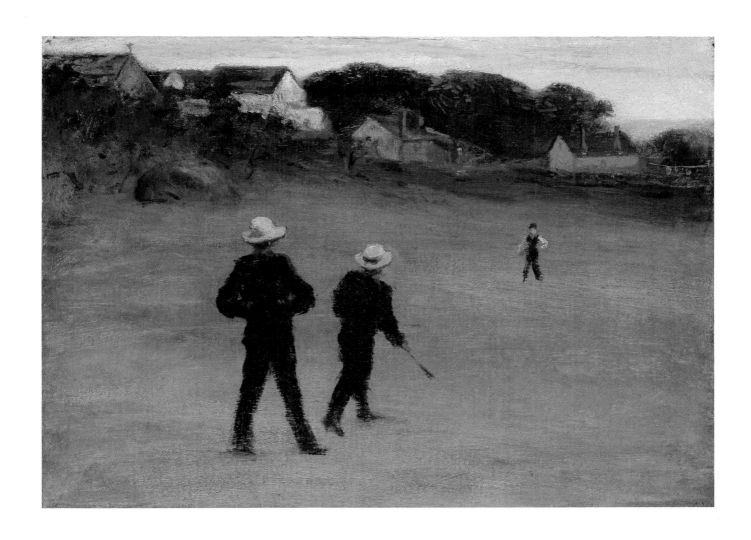

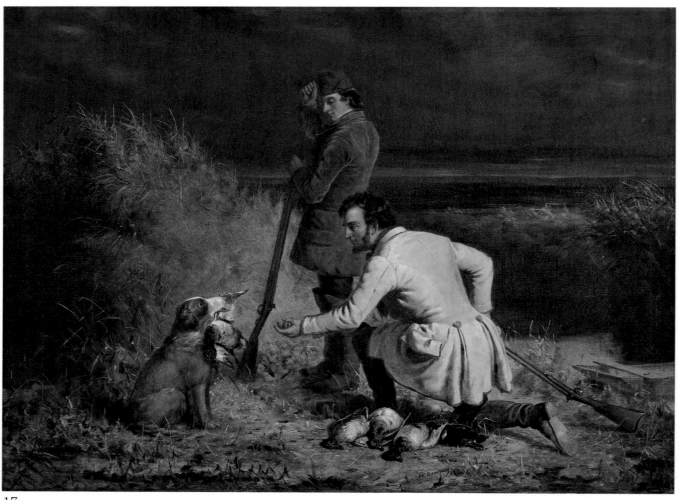

17.

William Ranney

American (1813–1857)
Duck Shooting, 1850
Oil on canvas, 30¼ x 40⅜ in.
The Corcoran Gallery of Art,
Washington, D.C.
Gift of William Wilson Corcoran

William Ranney's *Duck Shooting* is well-qualified for inclusion in an exhibition on the theme of sport in art. The artist portrays his subject with lively feeling, and it appears to have had close personal association. The kneeling figure has been identified as his brother and the landscape may well represent a scene near his studio, overlooking the meadows of Hackensack, New Jersey. Ranney was one of the founders of the New York Cricket Club in 1845 and maintained a keen interest in the sporting world.

David W. Scott
Acting Director
The Corcoran Gallery of Art

18–21.

Winslow Homer

American (1874–1897)

(18) *Trappers Resting*, 1874
Watercolor on paper, 9⅝ x
13¾ in.

(19) *Guide Carrying a Deer*, 1891
Watercolor on paper, 14 x 20 in.

(20) *Pickerel Fishing*, 1892
Watercolor on paper, 10¾ x
19⅜ in.

(21) *Young Ducks*, 1897
Watercolor on paper, 13⅞ x
21 in.

Portland Museum of Art,
Portland, Maine
Bequest of Charles Shipman
Payson, 1988

The Portland Museum of Art is pleased to be represented in the exhibition and publication *Sport in Art from American Museums* with the work of Winslow Homer, an artist who spent the last three decades of his life in Maine at Prout's Neck near Portland. Homer's watercolors are quintessential evocations of the spirit of the American great outdoors at the end of the nineteenth century. As an avid fisherman himself, Homer knew intimately both the details and ambience of the woods and lakes. His fluid painting style complements the sense of freedom and openness of his subjects.

The Portland Museum cherishes its watercolors and guards them against the adverse effects of light. For this reason the museum elected to lend four different watercolors, one for presentation at each exhibition venue, so that no one work receives undue exposure. Each has a verve and vitality that are difficult to match and each is an extraordinarily appealing depiction of American sport.

Barbara Shissler Nosanow
Director
Portland Museum of Art

See colorplates on overleaf.

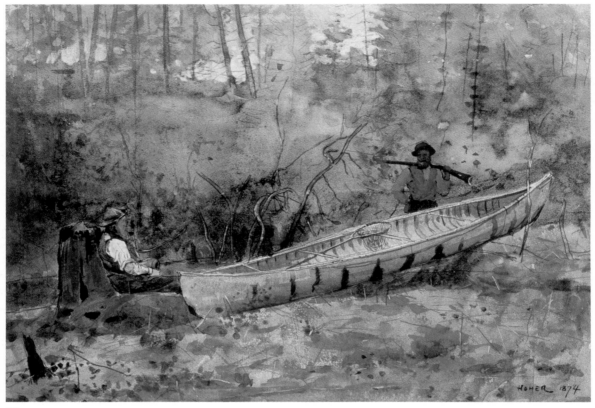

18.

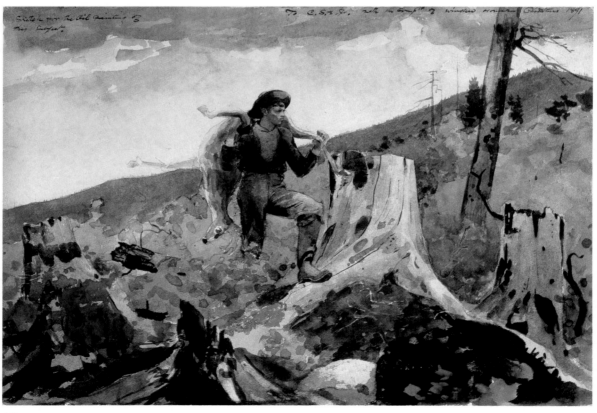

19.

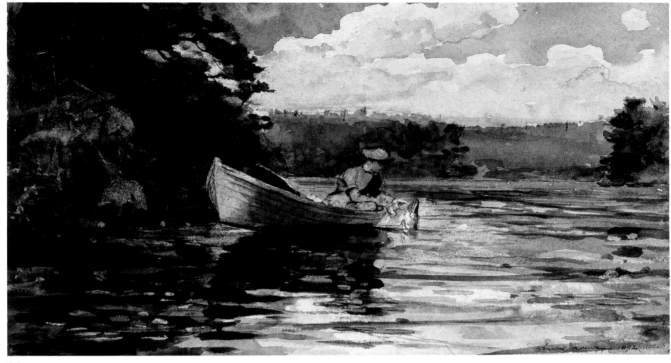

20.

21.

22.

John O'Brien Inman

American (1828–1896)
Moonlight Skating—Central Park,
the Terrace and Lake, 1878
Oil on canvas, 30 x 48 in.
Museum of the City of New York
Anonymous gift (49.415.2)

Long practiced as a sport in Holland and Scotland, ice-skating developed as a popular pastime in the United States during the nineteenth century, after the Civil War. The lakes and ponds incorporated into urban parks of the period proved ideal for the new skate that had been invented in 1850, providing the wearer with greater control and speed. Artists were quick to respond to the pictorial possibilities of the skating fad, which challenged them to capture the gliding motion of the colorfully clad performers.

This moonlight scene in Central Park, against the background of the newly completed terrace north of the Mall, with the Bethesda Fountain rising behind the skaters as they crisscross the lake, is one of the few genre paintings documented to John O'Brien Inman, the son of the portraitist Henry Inman. The painting probably dates to 1870, following the artist's return from a twelve-year European sojourn. Inman enjoyed considerable recognition abroad, particularly in Paris. *Moonlight Skating* shows a decided French influence in the treatment of the figures, and represents an outstanding contribution to the emerging school of painting which drew its main inspiration from the New York City scene.

Robert R. Macdonald
Director
Museum of the City of New York

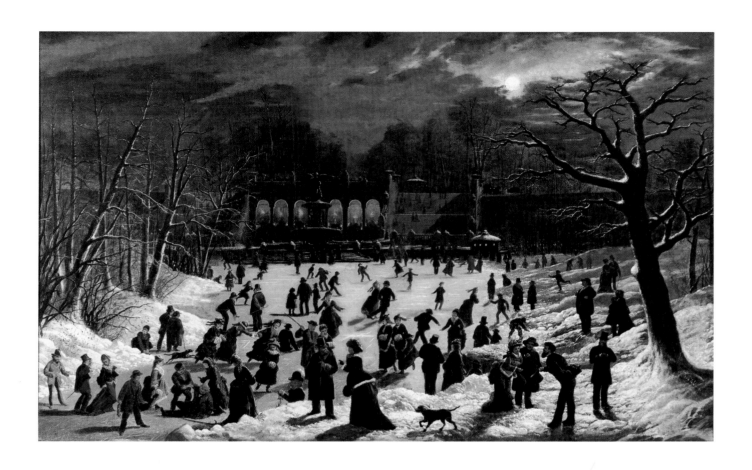

23.

William Michael Harnett

American, born in Ireland
(1848–1892)
Merganser, 1883
Oil on canvas, 34⅛ x 20½ in.
San Diego Museum of Art
Gift of Gerald and Inez Grant
Parker Foundation
(SDMA no. 72:185)

America's painter of illusion, William Michael Harnett, earned his reputation as the greatest realist of the nineteenth century by transforming with intense reality the simple still life into a convincing and ever-present example of pictorial Americana. Harnett's first efforts were appreciated primarily by saloon keepers; by the end of his life, however, his works were internationally admired and collected.

Unlike Harnett's paintings, where detail and texture are abundant, facts about the artist himself are few. Irish-born, Harnett pursued a career in Philadelphia as a silver engraver until he opened a painting studio in 1875. Prior to settling in New York, Harnett spent seven years in Europe, from 1880 to 1886, where he had great success at the Paris Salon of 1885 with his painting *After the Hunt.*

Especially active in Munich for the four years beginning in 1881, Harnett's work showed distinct changes in size and quality. Formats became smaller and objects more limited. Writers about art at the time discerned a richer, more painterly use of the artist's medium. Images of the hunt replaced the themes of his earlier work—smoking scenes, writing-table still lifes, and trompe l'oeil paper money were no longer apparent. Objects, usually a single image, such as dead birds, ducks, and rabbits now filled his pictures. Harnett's works showed the same passion for representing the object as one finds in seventeenth-century Dutch still-life painting, known firsthand by Harnett from his European travels.

The San Diego Museum of Art's painting, *Merganser,* depicts a fish-eating duck and is one of two commissioned by a Mr. Hastings of Munich. The other of the pair, *Mallard,* is (according to Harnett scholar Alfred Frankenstein) in the collection of the National Gallery of Canada, Ottawa.

Steven L. Brezzo
Director
San Diego Museum of Art

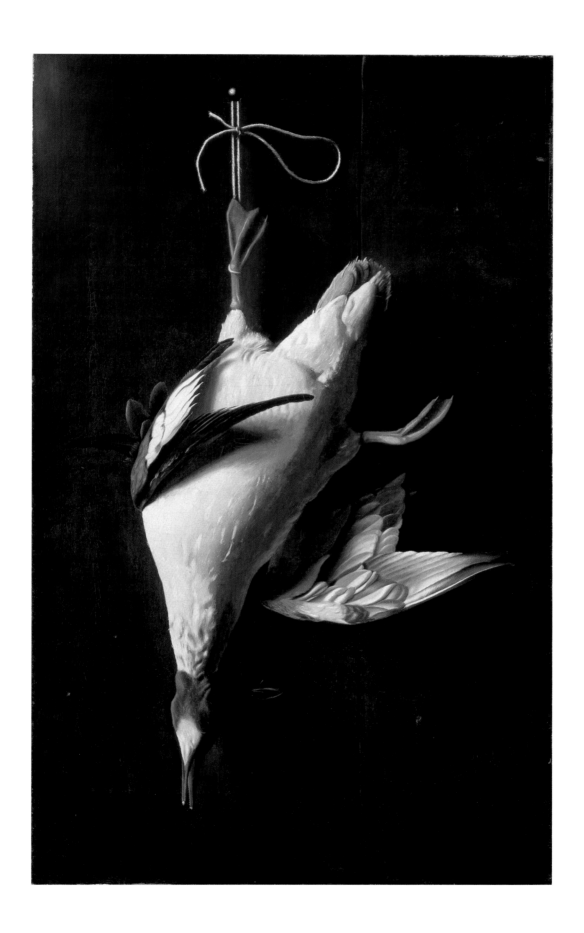

24.

John Rogers

American (1829–1904)
Football, 1891
Plaster, 16 in. high
Signed: John Rogers,
14 West 12th Street, NY;
inscribed in base: Football
The New-York Historical Society,
New York

John Rogers created a large group of anecdotal genre sculpture that typified the ethos of the nineteenth century. During his career, which began in New York City in 1859 and spanned three decades, he produced over eighty figural groups depicting Civil War themes, scenes of everyday life, literary subjects, and portraits. The New-York Historical Society owns over 125 bronze and plaster sculpture groups by Rogers.

Football was modeled at the height of Rogers's career, and the sophisticated technique exhibited by the figures reflects his training in Europe. Three of Rogers's five sons—all of whom attended Yale University—posed for the sculpture with William Herbert Corbin (1864–1945), then captain of the Yale football team. Rogers's choice of subject reflects the nineteenth-century view of play and organized physical exercise as beneficial and perhaps even necessary to proper character development. Athletes who excelled on the baseball diamond or the football gridiron, or in the boxing ring were popular heroes of the day and now joined political, military, and cultural leaders as subjects for artists.

As is consistent with football attire of the period, the players in Rogers's piece do not wear helmets or shoulder pads. Quite different from the game we know today, the early American game of football evolved from English rugby. It became popular as an early nineteenth-century college game and, by the 1870s and 1880s, had spread among universities as an organized sport. The rules of the game changed during the 1890s, and 1897 marked the advent of professional football.

Rogers's designs were patented and mass-produced for popular consumption in bronze, plaster, and parian. His works were priced from $3.00 to $20.00 to appeal to the average buyer; *Football* was produced only in plaster and sold for $10.00. Unfortunately, Rogers became paralyzed in 1893 and was forced into an early retirement, thus ending his highly successful career.

Holly Hotchner
Director
The New-York Historical Society

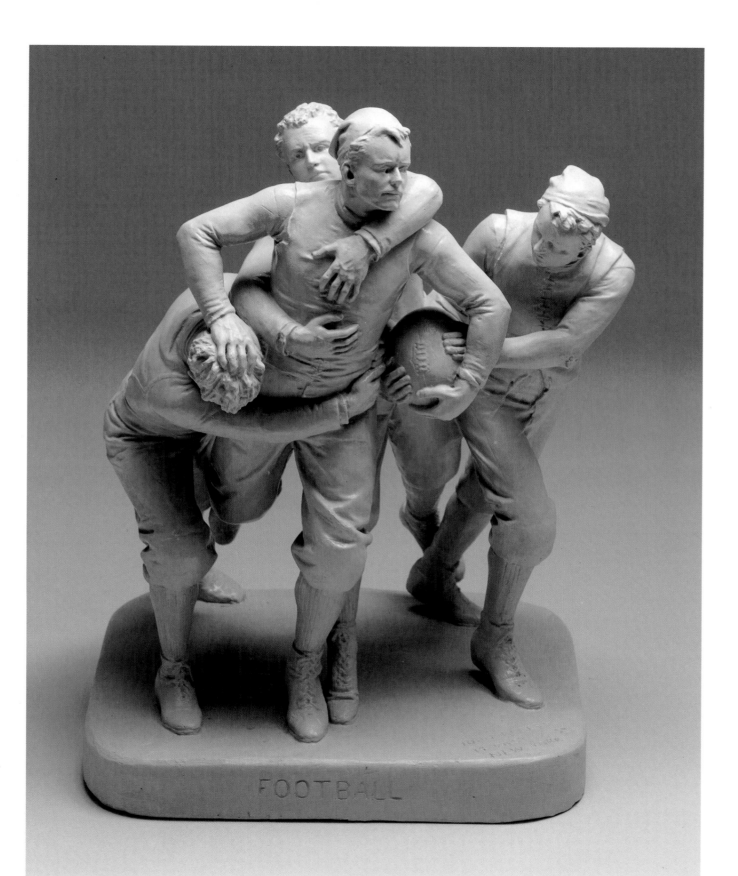

FOOTBALL

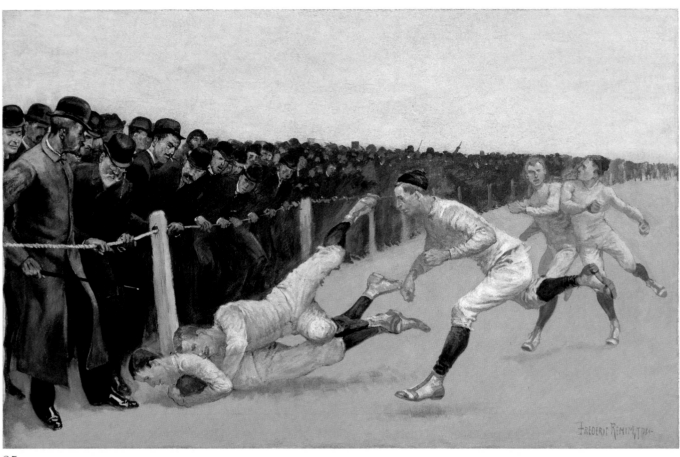

25.

Frederic Remington

American (1861–1909)
Touchdown, Yale vs. Princeton,
Thanksgiving Day, November 27,
1890, Yale 32, Princeton 0
Oil on canvas, 22 x 32⁹⁄₁₆ in.
Signed l.r.: Frederic Remington
Yale University Art Gallery,
New Haven, Conn.
Whitney Collections of Sporting
Art, given in memory of Harry
Payne Whitney, B.A. 1894, and
Payne Whitney, B.A. 1898, by
Francis P. Garvan, B.A. 1897,
M.A. (Hon.) 1922 (1932.264)

Frederic Remington—painter of subjects Americans think of as being quintessentially American—offers here a portrait of the rough-and-tumble collegiate athletics of an earlier era. Although differing from Remington's most familiar subjects drawn from life in the West, the event depicted here is a fundamental part of American life. Friendly rivalry and good sportsmanship abound as two great centers of learning face off on the playing field. Remington, who would receive a Bachelor of Fine Arts degree from Yale a decade after this work was painted, has here captured the essence of an American rite of passage.

Mary Gardner Neill
The Henry J. Heinz II Director
Yale University Art Gallery

26.

Robert William Vonnoh

American (1858–1933)
The Ring, 1892
Oil on canvas, 60½ x 72½ in.
Museo de Arte de Ponce (Luis
A. Ferre Foundation); Ponce, P.R.
Gift of the Banco de Ponce (68.0718)

Robert Vonnoh, portrait painter of leading notabilities of his day, also combined genre and landscape as in *The Ring.* The landscape background here shows that Vonnoh, as a result of visits to France, had mastered Impressionist technique—yet with a difference. French Impressionist emphasis was on light conceived as a flickering network of diminutive patches of pure color. However, in *The Ring,* despite its luminous quality, it is sentiment—in the finest sense—that counts above all. Our attention is engaged on the young women, two of whom have interrupted a game of tennis, a genteel sport highly recommendable for turn-of-the-century ladies of the leisure class, to admire their companion's engagement ring. The work's fine Impressionist technique contrasts its distinctly American genre rendering, with tennis being Vonnoh's pretext to make a statement of social import.

René Taylor
Director Emeritus, Acting Director
Museo de Arte de Ponce

27.

Thomas Eakins

American (1844–1916)
Billy Smith, 1898
Oil on canvas, 21 x 17 in.
Wichita Art Museum, Wichita, Kans.
Roland P. Murdock Collection
(M16.40)

Thomas Eakins painted this portrait of Billy Smith in preparation for his work on a large-scale genre scene, *Between Rounds,* of a fighter resting in the ring at the old Philadelphia Sports Arena. The portrait, however, stands as a finished painting. Inscribed to ''Billy Smith from his friend Thomas Eakins,'' it provides insight into both the character of the sitter and the character of the artist.

In 1898 the sport of boxing presented an unlikely subject for serious painting, unrelated as it was to the concerns of the newly fashionable and genteel impressionism. But Thomas Eakins, that ''Realist of Realists,'' as Billy Smith called him, found it a natural. Eakins himself was an avid sportsman who engaged in sailing, sculling, and hunting and made these activities the focus of his early painting.

Eakins could hardly have avoided taking an interest in boxing. The Philadelphia Sports Arena was located right across the street from the Pennsylvania Academy of the Fine Arts, where the artist taught. Moreover, at the time Eakins began his series of works about boxing, the game had arrived as the leading passion for Philadelphia sports fans. The city boasted one of the liveliest fight scenes in the country and a host of major fighters.

''Turkey Point'' Billy Smith, from Turkey Point in South Philadelphia, was not a celebrity but was definitely a professional. He was good enough to have made a living prizefighting for ten years and to have been matched against three champions in his featherweight class. Eakins must have taken an immediate liking to the man because he gave the portrait to Smith as a gift and the two became lifelong friends.

It is easy to see that Eakins didn't choose Smith as his model because he was looking for an example of physical beauty or even for the stereotype of brute force so easily associated with the fighter. The particular moment represented in the portrait, as well as its composition, emphasizes qualities of thought and concentration rather than any extraordinary display of strength. It was Billy Smith, the workmanlike professional, who impressed Thomas Eakins. The artist's meditative, internalized presentation of Smith the boxer projects the same reverence for the frailty and dignity of the individual expressed in so many of Eakins's portraits of musicians, scholars, physicians, and artists.

In 1940, Billy Smith sold Eakins's portrait of him to the Walker Art Galleries in New York. Mrs. Elizabeth Navas, trustee of the Murdock estate, purchased this portrait and two other paintings by Eakins—*Starting Out After Rail* (watercolor, 1874) and *Portrait of Mrs. Mary Hallock Greenewalt* (1903)—for the Roland P. Murdock Collection, Wichita.

J. Richard Gruber
Director
Wichita Art Museum

26.

Robert William Vonnoh

American (1858–1933)
The Ring, 1892
Oil on canvas, 60½ x 72½ in.
Museo de Arte de Ponce (Luis
A. Ferre Foundation); Ponce, P.R.
Gift of the Banco de Ponce (68.0718)

Robert Vonnoh, portrait painter of leading notabilities of his day, also combined genre and landscape as in *The Ring*. The landscape background here shows that Vonnoh, as a result of visits to France, had mastered Impressionist technique—yet with a difference. French Impressionist emphasis was on light conceived as a flickering network of diminutive patches of pure color. However, in *The Ring*, despite its luminous quality, it is sentiment—in the finest sense—that counts above all. Our attention is engaged on the young women, two of whom have interrupted a game of tennis, a genteel sport highly recommendable for turn-of-the-century ladies of the leisure class, to admire their companion's engagement ring. The work's fine Impressionist technique contrasts its distinctly American genre rendering, with tennis being Vonnoh's pretext to make a statement of social import.

René Taylor
Director Emeritus, Acting Director
Museo de Arte de Ponce

27.

Thomas Eakins

American (1844–1916)
Billy Smith, 1898
Oil on canvas, 21 x 17 in.
Wichita Art Museum, Wichita, Kans.
Roland P. Murdock Collection
(M16.40)

Thomas Eakins painted this portrait of Billy Smith in preparation for his work on a large-scale genre scene, *Between Rounds,* of a fighter resting in the ring at the old Philadelphia Sports Arena. The portrait, however, stands as a finished painting. Inscribed to "Billy Smith from his friend Thomas Eakins," it provides insight into both the character of the sitter and the character of the artist.

In 1898 the sport of boxing presented an unlikely subject for serious painting, unrelated as it was to the concerns of the newly fashionable and genteel impressionism. But Thomas Eakins, that "Realist of Realists," as Billy Smith called him, found it a natural. Eakins himself was an avid sportsman who engaged in sailing, sculling, and hunting and made these activities the focus of his early painting.

Eakins could hardly have avoided taking an interest in boxing. The Philadelphia Sports Arena was located right across the street from the Pennsylvania Academy of the Fine Arts, where the artist taught. Moreover, at the time Eakins began his series of works about boxing, the game had arrived as the leading passion for Philadelphia sports fans. The city boasted one of the liveliest fight scenes in the country and a host of major fighters.

"Turkey Point" Billy Smith, from Turkey Point in South Philadelphia, was not a celebrity but was definitely a professional. He was good enough to have made a living prizefighting for ten years and to have been matched against three champions in his featherweight class. Eakins must have taken an immediate liking to the man because he gave the portrait to Smith as a gift and the two became lifelong friends.

It is easy to see that Eakins didn't choose Smith as his model because he was looking for an example of physical beauty or even for the stereotype of brute force so easily associated with the fighter. The particular moment represented in the portrait, as well as its composition, emphasizes qualities of thought and concentration rather than any extraordinary display of strength. It was Billy Smith, the workmanlike professional, who impressed Thomas Eakins. The artist's meditative, internalized presentation of Smith the boxer projects the same reverence for the frailty and dignity of the individual expressed in so many of Eakins's portraits of musicians, scholars, physicians, and artists.

In 1940, Billy Smith sold Eakins's portrait of him to the Walker Art Galleries in New York. Mrs. Elizabeth Navas, trustee of the Murdock estate, purchased this portrait and two other paintings by Eakins—*Starting Out After Rail* (watercolor, 1874) and *Portrait of Mrs. Mary Hallock Greenewalt* (1903)—for the Roland P. Murdock Collection, Wichita.

J. Richard Gruber
Director
Wichita Art Museum

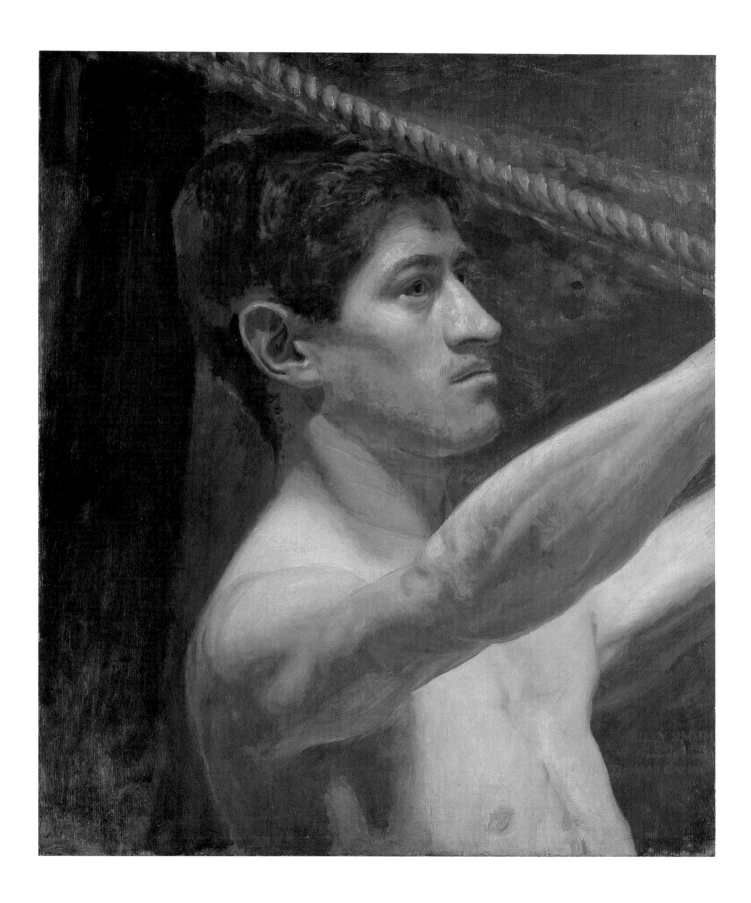

28.

Thomas Eakins

American (1844–1916)
The Wrestlers, ca. 1899
Oil on canvas, 16¹⁄₁₆ x 20¹⁄₁₆ in.
Inscribed in another hand,
probably by Mrs. Eakins, l.r.: T. E.
Los Angeles County Museum of Art
Mr. and Mrs. William Preston
Harrison Collection (48.32.1)

Thomas Eakins was thoroughly trained in the academic system of preparing extensive studies before beginning a major painting. He practiced this approach all his life and taught it to his pupils. Before undertaking his paintings of boxers and other athletes that he painted at the end of the 1890s, Eakins spent hours watching the men, studying their movements in light of his knowledge of anatomy.

For this and two related works, Eakins had two wrestlers posed for several photographs. He copied the photograph of this pose almost directly onto a canvas (Philadelphia Museum of Art), the purpose of which would have been to clarify the details of musculature that were unclear in the photograph. The next step in the preparatory process was this painting, which served as a compositional sketch. In it, Eakins worked out the placement of the figures as they would appear in the finished painting (*The Wrestlers*, Columbus Museum of Art; see cat. no. 29).

Achieving the proper balance within the composition was especially important to Eakins at this point in his career, because of his increased awareness of surface design and internal structure. Like most artists at the turn of the century, Eakins introduced into his paintings devices that had the effect of compromising the illusion of depth while creating a more even, overall, decorative pattern. In this example, he did so by the placement of the rower in the extreme upper left corner and by cropping the standing man with the top edge of the painting, which pulls what is normally the part farthest away into the same plane as that of the foreground figures of the wrestlers.

Eakins gave the final painting (Columbus Museum of Art) to the National Academy of Design as a diploma painting, satisfying a condition of his election as member in 1902. The Los Angeles County Museum of Art's preparatory work was originally bought by William Preston Harrison, on the advice of Childe Hassam, when it was exhibited in Los Angeles.

Earl A. Powell III
Director
Los Angeles County
Museum of Art

29.

Thomas Eakins

American (1844–1916)
The Wrestlers, 1899
Oil on canvas, 48⅜ x 60 in.
Signed and dated u.r.: Eakins/1899
Columbus Museum of Art,
Columbus, Ohio
Museum Purchase: Derby Fund,
1970 (70.38)

Renowned for his rugged realism, Thomas Eakins was a distinguished painter of athletic themes. His interest in anatomy naturally drew him to the various sporting events of his native Philadelphia. In 1898–99, Eakins painted several boxing and wrestling pictures which are notable for their paradoxical qualities of stillness and repose. Intertwined in combat, the wrestlers in the Columbus Museum's painting show little feeling of action. The painting is not so much a depiction of a sporting event as a symbol of persistent struggle with the real, material world.

The models for *The Wrestlers* were members of the Quaker City Athletic Club in Philadelphia. They were selected and posed by a local sportswriter, Clarence Cranmer, who later described the occasion: ''Joseph McCann is the man on the top—being a boxing champion I had to pose him in the winning position, with a half nelson and crotch hold.'' Working from a photograph, Eakins reveled in the anatomical challenges presented by his subjects' lean nude bodies. Eakins's sporting subjects constitute the apogee of the American depiction of the male nude in the nineteenth century.

Merribell Parsons
Director
Columbus Museum of Art

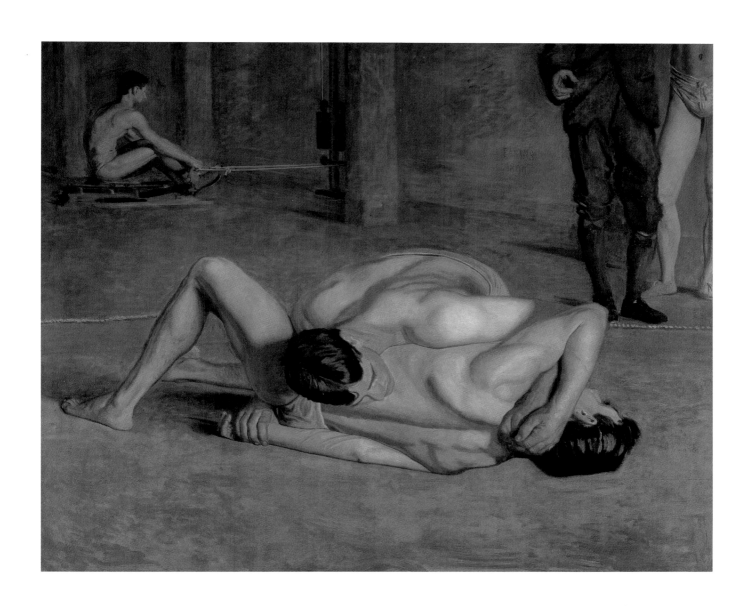

30.

Henri Rousseau

French (1844–1916)
The Football Players, 1908
Oil on canvas, 39½ x 31⅝ in.
Solomon R. Guggenheim Museum,
New York

Henri Rousseau's engaging *The Football Players* of 1908 was probably inspired by England's first rugby match held against France in Paris in the spring of that year. The imaginary commemoration of this event might explain the unique nature of the work within the artist's oeuvre, the only composition in which the figures are animated. It has been suggested that Rousseau may have based his figures on a published cartoon of an earlier rugby match, resulting in a rather amusing, ballet-like effect.

Rousseau's painting corresponded with a great vogue at the beginning of this century for the game of rugby, which had just become an internationally competitive sport. The Douanier's work probably inspired several other interpretations of the sport: Albert Gleizes's *The Football Players* (1912–15), possibly depicting the 1912 match of England and Ireland against France; Robert Delaunay's *Cardiff Team* (1913), based on the match between Wales and France; and André Lhote's *Football* (1920).

Rugby has recently enjoyed a revival of interest in this country, especially at colleges and universities. The origins of the game date back to the beginning of the nineteenth century. In 1823 a young Englishman named William Webb Ellis picked up the ball in the midst of a soccer game at the Rugby School, and with what he later called ''a fine disregard'' for the existing rules of the game, ran with the ball. Recently, art historian Kirk Varnedoe, a rugby player himself, has adopted the words of the young Rugby student as the title for his book-length analysis of the origins of modern art, *A Fine Disregard: What Makes Modern Art Modern* (1990). Inspiration has come full circle.

Thomas Krens
Director
Solomon R. Guggenheim Museum

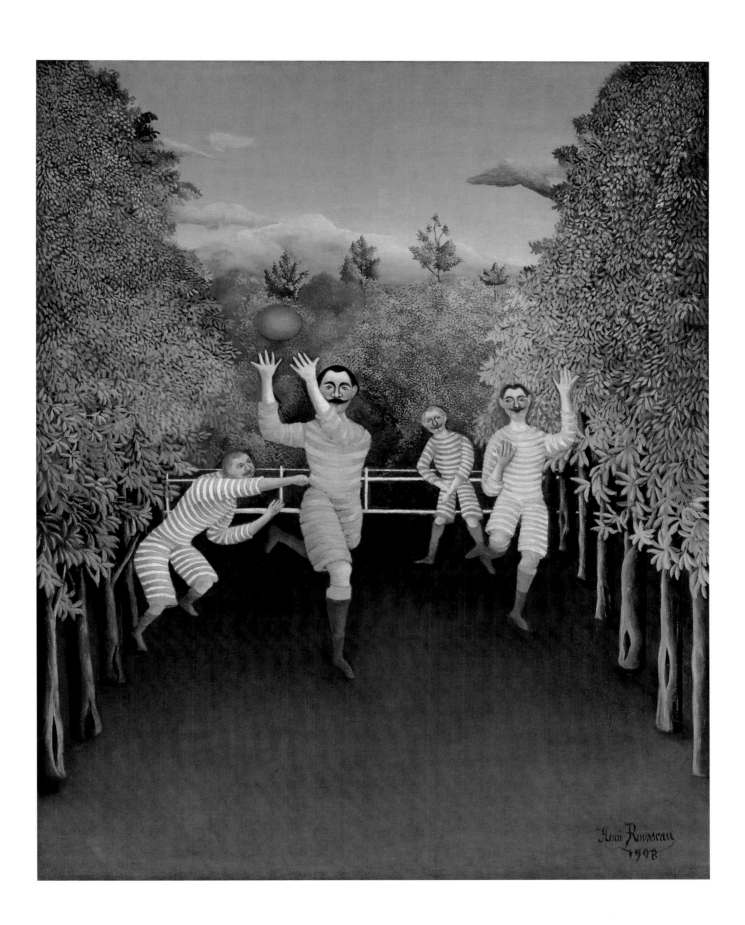

31.

Charles Grafly

American (1862–1929)
The Oarsman, 1910
Bronze, 38¼ x 12 x 9½ in.
The Pennsylvania Academy of
the Fine Arts, Philadelphia
Gift of Dorothy Grafly

The Oarsman, a figure of a rower, was modeled in clay by the prominent sculptor Charles Grafly in the summer of 1910 as a demonstration for students in a class he offered at his Massachusetts studio. Rowing subjects had been especially popular in the late nineteenth century with Philadelphia painter Thomas Eakins, Grafly's teacher at the Pennsylvania Academy of the Fine Arts. Because of their well-developed musculature, oarsmen were excellent models. Although *The Oarsman* appears to be an anatomical study, it was cast in bronze by the renowned lost-wax foundry Roman Bronze Works in New York, and widely exhibited. This is the only bronze in the edition and it has a translucent red-brown patina.

After studying at the Pennsylvania Academy in the 1880s, Grafly went to Paris, like many of his generation, for further study. Upon his return, he set up a sculpture department at the academy, where he taught for the next thirty-eight years. He also commuted to a teaching job at the Museum of Fine Arts in Boston and taught summers at his studio in Gloucester, Massachusetts. Grafly continued to stress the fundamentals that he had learned from Eakins and the academic tradition: the importance of working from the nude model as well as a thorough training in anatomy.

Linda Bantel
Director
The Pennsylvania Academy
of the Fine Arts

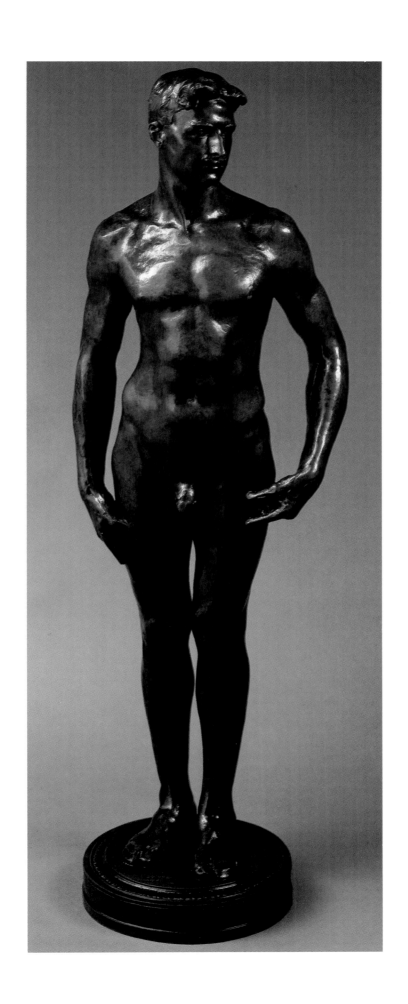

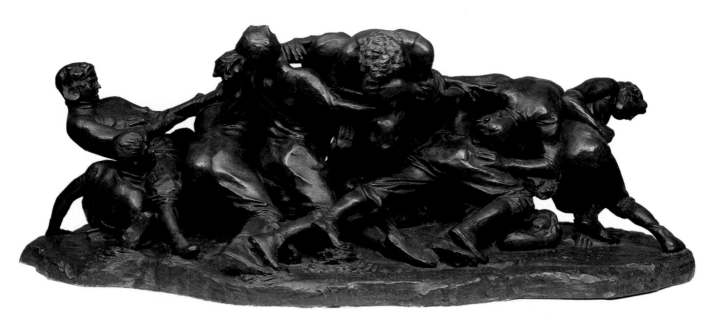

32.

R. Tait McKenzie

American (1867–1938)
Onslaught, 1911
Bronze, 15 x 36 x 21 in.
The Lloyd P. Jones Gallery of the
Sculpture of R. Tait McKenzie,
University of Pennsylvania
Collection of Art, Philadelphia

*O*nslaught—part of the University of Pennsylvania's Lloyd P. Jones Gallery of the Sculpture of R. Tait McKenzie, America's foremost sculptor of sports—was started in 1906 and cast in bronze early in 1911. The sculpture is documented with a detailed description of the group in play, including the identification of many of the models who were University of Pennsylvania football players. The composition is dense and charged with tension, arising from McKenzie's ability to capture the moment and impact of opposing teams of football players colliding into each other.

The figures seen in the work display McKenzie's sensitivity to rendering anatomical forms, derived from his medical training, his interest in physical education, and his finely developed artistic abilities. *Onslaught* is indeed a piece that the university can be proud of. It embodies the spirit and values of athleticism which were encouraged by Benjamin Franklin at the inception of the university.

Jacqueline Jacovini
University of Pennsylvania
Collection of Art

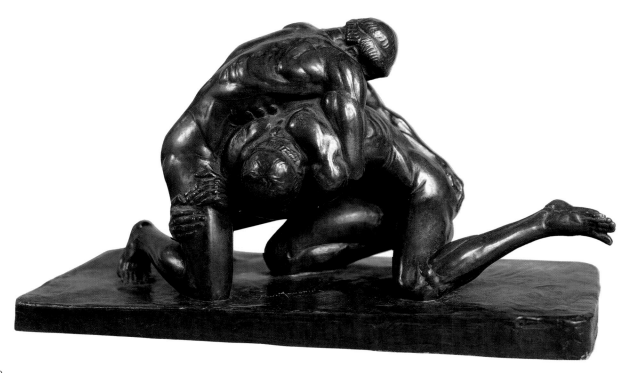

33.

Paul Manship

American (1885–1966)
Wrestlers, 1914
Bronze, 9¼ x 16¼ x 7½ in.
Dayton Art Institute, Dayton, Ohio
Bequest of the Honorable
Jefferson Patterson (79.71)

Paul Manship, an American master of the Art Deco movement, at the age of twenty-three won a fellowship to the American Academy in Rome, where he studied classical art. Rising to success quickly, he became a much-praised sculptor. In the 1920s his work was accepted in the Exposition Internationale des Arts Décoratifs et Industriels Modernes (the show that gave us the term Art Deco) in Paris. In the 1930s his monumental commissions included such works as *Prometheus* at Rockefeller Center and the 1939 World's Fair in New York. His popularity waned, however, after World War II until the rediscovery of Art Deco in the 1970s.

Manship studied at the Pennsylvania Academy of the Fine Arts in Philadelphia with Charles Grafly during 1907–08. It was during this period that Manship first worked with the theme of wrestlers—a 1908 bronze sketch reflecting the influence of Rodin depicts a match of antiquity. In 1915 Manship cast an edition of six *Wrestlers*, a rare work that hardly depicts a mythic feeling. The lasting appeal of Manship's work is expressed here in its irrepressible strength and energy.

Bruce H. Evans
Director
Dayton Art Institute

34.

Alexander Archipenko

American, born in Russia
(1887–1964)
Boxers (La Lutte or the Fight), 1914
Bronze, 23½ x 18 in.
Milwaukee Art Museum
Purchase, Virginia Booth Vogel
Acquisition Fund

Although Alexander Archipenko rejected the Cubist label applied to his works, his early sculpture *Boxers* is widely considered one of the key achievements of early Cubist sculpture. Born in Russia, Archipenko studied at the Kiev Academy and in Moscow before immigrating to Paris in 1908. Shortly after his arrival, he came into contact with a group of young artists who were deeply impressed by the experiments of Picasso and Braque and determined to achieve their own variants of the slightly older artists' analytical, highly geometricized vision. Calling themselves the *Section d'Or* (Golden Section) when exhibiting together at the Galerie La Boétie in 1912, the group included Fernand Léger, Jacques Villon, Raymond Duchamp-Villon, Marcel Duchamp, Robert Delaunay, and Francis Picabia. As indicated by their choice of names—''golden'' referred to the Golden Mean, or ideal proportions, of classical Greece—these artists sought to reinvest art with a sense of ideal form. However, the geometry of these Parisian Cubists produced a form altogether different from the classical by emphasizing not one geometric standard but many. The *Section d'Or* artists presented a constantly changing panoply of active, ''modern'' subjects rendered by an equally active geometric form.

Archipenko's efforts to incorporate the new geometric vision into sculpture were undoubtedly influenced by Picasso, Raymond Duchamp-Villon, and the Italian Futurists who held their first exhibition in Paris in 1912. Both Duchamp-Villon and the Futurists attempted to combine Cubist-inspired geometric form with a sense of movement, often a mechanical movement suggestive of the advancing technology of the twentieth century. Fully a part of all these experiments, Archipenko exhibited at the Salon des Indépendants from 1910 to 1914, and by 1912 was exhibiting sculpture which provocatively suggested form through the complex interplay of convex and concave surfaces or positive and negative spaces.

Boxers, from 1914, is one of his most complete and compelling achievements, representing movement through space and time in the concrete medium of sculpture. Moving around the sculpture, one can discern the suggested forms of two pugilists locked in a combat of thrust and counterthrust movements. The void at the sculpture's center suggests both the space between the fighters and space as a field of action for the blows which move around and through it. Without giving us a ''picture'' of a sporting event, Archipenko translates the movement, tension, and excitement of a boxing match into a fluid exploration of geometric forms, thereby creating a new realm of possibility for sculpture.

Boxers stands as perhaps the most original and masterful example of Archipenko's early career in sculpture. Acquired from the artist's widow, this work is the seventh of eight casts.

Russell Bowman
Director
Milwaukee Art Museum

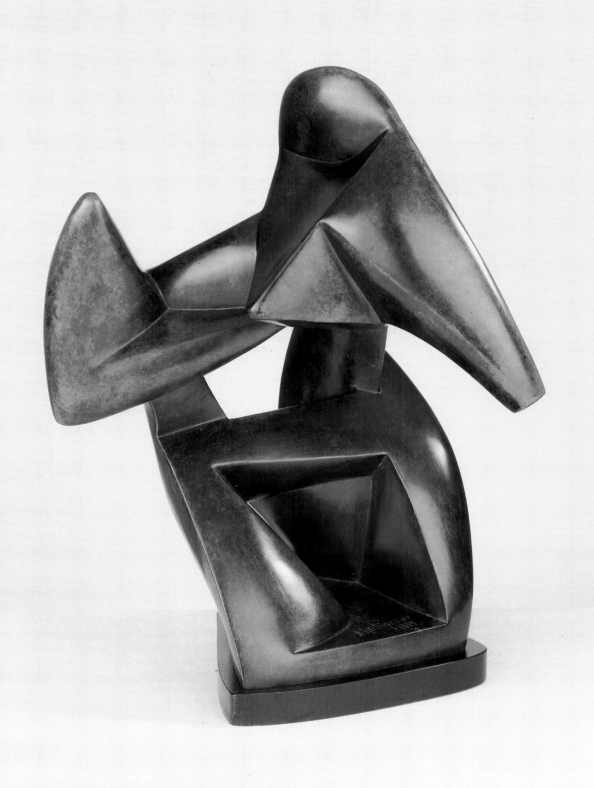

35.

George Bellows

American (1882–1925)
In a Rowboat, 1916
Oil on canvas, 30½ x 44¼ in.
Montclair Art Museum,
Montclair, N.J.
Purchase made possible through
a special gift from Mr. and Mrs.
H. St. John Webb (64.37)

Realist painter George Bellows was born in Columbus, Ohio, and moved to New York in 1904, when he was twenty-two. Except for summer excursions, he lived and worked in New York the rest of his life. During his early years in the city he studied with Robert Henri. Although not officially one of the Eight, a group of artists headed by Henri who opposed the conservative art establishment of the time, Bellows is stylistically and aesthetically associated with the group. His dynamic interpretation; vigorous, broad brushwork; and use of subject matter drawn from experiences of the common man echo the attitudes of the Henri circle. Yet, unlike many of his contemporaries and Henri himself, Bellows never went abroad to study art, preferring to infuse his paintings with a character that was more uniquely American.

Bellows's style and philosophy are well expressed in his painting *In a Rowboat.* Painted during the artist's summer vacation in the small coastal town of Camden, Maine, it shows remarkable drama in its stark contrast of light and dark. With the tumultuous environment as focus, Bellows emphasized the drama of the moment by adding four figures in a seemingly perilous situation.

The work actually dramatizes an incident that occurred outside Camden harbor. Accompanied by his wife, Emma, young daughter, Anne, and close friend artist Leon Kroll, Bellows was returning from a morning's outing when a sudden squall pounced down from the hills with malevolent splendor. Bellows and Kroll were so taken with the spectacle that they momentarily forgot their perilous position. Bounding waves began dumping water into the already overloaded craft as Kroll attempted to steady the tiny boat with the oars, while Emma, who could not swim a stroke, bailed as fast as she could.

In Bellows's short career (he died of a ruptured appendix at age forty-two), his ability to seize the spirit of place through powerful brushwork, emphasis on sensual texture, and play of light—as in *In a Rowboat*—gained him recognition as a model of a new mode of American art.

Robert J. Koenig
Director
Montclair Art Museum

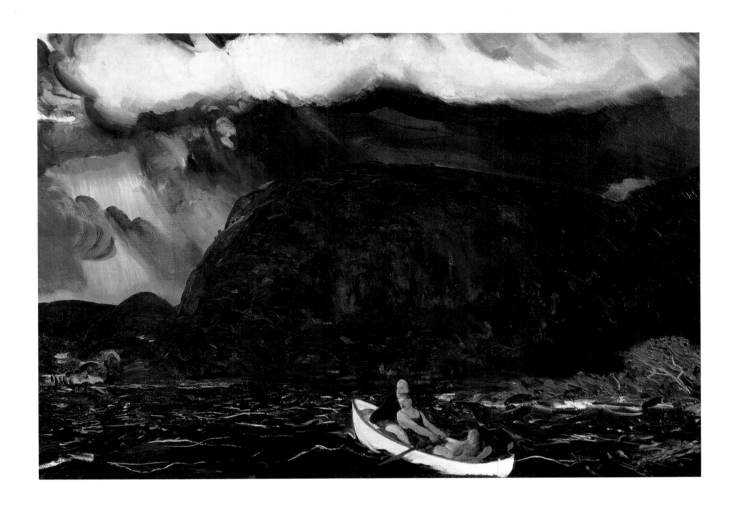

George Bellows

American (1882–1925)
Tennis Tournament, 1920
Oil on canvas, 59 x 66 in.
National Gallery of Art,
Washington, D.C.
Collection of Mr. and Mrs.
Paul Mellon (1983.1.5)

George Bellows was a robust and vigorous man, and throughout his career was drawn to subjects that centered on the most energetically demanding of human pursuits. In his masterful early paintings, the compositions often focus on incidents of powerful physical force—men straining to lay the foundations of great buildings, boxers furiously exchanging blows, dockworkers loading and unloading cargo. More than any other American painter of his day, Bellows combined a mastery of fluid brushwork with an unerring instinct for expressing the essence of a single energetic moment. Nowhere did that special mix of talents serve him better than in his striking images of sporting events.

Bellows knew and loved tennis. While summering with his family in Middletown, Rhode Island, in 1919 he often went to the Casino in my native town of Newport to watch players like the "California Comet," Maurice Evans McLoughlin, one of the stars of American tennis. (The Casino, incidentally, designed by the notable American architect Stanford White, still functions today for lawn tennis championships and houses the Tennis Hall of Fame.)

Tennis was changing rapidly in those years. Although still associated by many with the exclusive games of rich society, McLoughlin and others who had grown up playing on urban public courts introduced a forceful style of play that made the game seem more and more a real, red-blooded sport. It is easy to imagine Bellows, ever the forthright champion of the common man and unabashed admirer of physical prowess, being intrigued and pleased by these developments. Certainly, in the sketches he made in the summer of 1919 and in paintings of the following year like *Tennis Tournament,* Bellows expended great creative energy in trying to capture the essence of the game. Even though unfinished, *Tennis Tournament* admirably presents the ingredients that give tennis its identity: the rich green grass of the court and lawn, the elegant fashions and demeanor of the spectators, the spirited ballet of the players, the vibrant light and air of a summer day. Yet the painting far transcends mere reportage; it also achieves a telling contrast between the tense energy of the foreground player, who is poised in the midst of a mighty stroke, and the more relaxed spectators arrayed like a frieze across the center of the painting. And it is ultimately Bellows's achievement of his dynamic equilibrium, this symbiotic balance between the physical energy of the isolated athlete and the mental concentration of the crowd, that makes *Tennis Tournament* such a memorable and successful image uniting art and sport.

J. Carter Brown
Director
National Gallery of Art

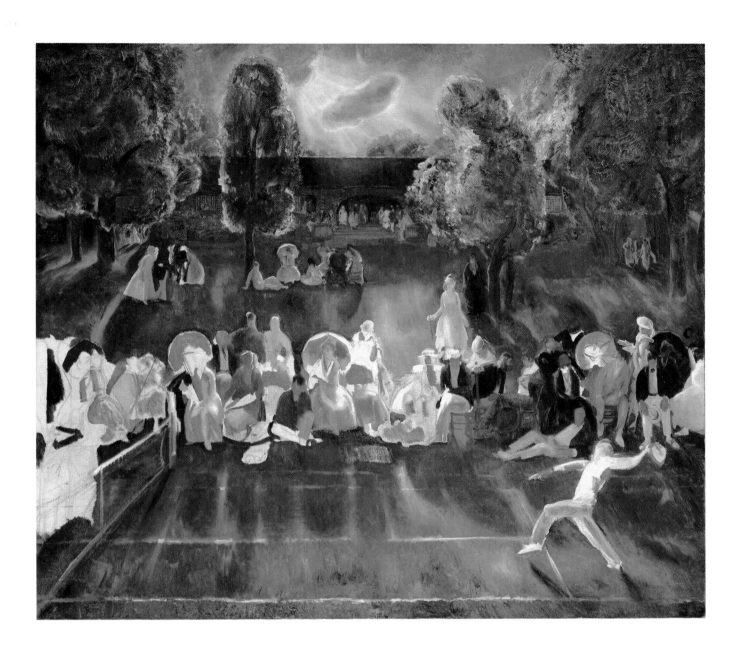

37.

Childe Hassam

American (1859–1935)
The Dune Hazard, No. 2, 1922
Oil on canvas, 24 x 44 in.
American Academy and Institute
of Arts and Letters, New York
The Childe Hassam Fund Bequest

Frederick Childe Hassam was an American Impressionist, although he routinely denied it: "...everybody who paints and sees is probably an impressionist." He left high school at sixteen to work in his native Boston, in the accounting department of the publishers Little, Brown & Co. It was not a successful match, and his kindly boss suggested he take up drawing, for which he seemed to have an aptitude. He apprenticed himself to a lithographer, and took art lessons at the Boston Arts Club and the Lowell Institute. In 1883, at the age of 24, he left Boston to study in Paris, dropping his first name enroute. After three years there, much of it experimenting with the new techniques he found French painters using, his work had changed considerably. Where it had been dark, with tight brush strokes, in the classical tradition, it was becoming looser, more open and lighter, more painterly. After several long stays in Paris, and now married, he settled in New York. By the 1890s he had become a successful painter, considered by many to be the leader of American Impressionism.

Hassam was a man of robust constitution, exceedingly fond of sports, particularly boxing, football, swimming, and golf. He had visited the Hamptons on Long Island many times and, in August 1919, he and his wife bought a house on Egypt Lane in East Hampton, in which they spent all their summers thereafter. His golf paintings were all done there, possibly at the Maidstone Club, which Hassam once described as a country club discovered by artists.

He was a founding member of the National Institute of Arts and Letters in 1898, and was inducted into the American Academy of Arts and Letters in 1920 (the two organizations merged in 1976). To the academy, he bequeathed the contents of his studio: several hundred oil paintings, decorative panels, watercolors, and pastels. He left instructions that these were to be sold from time to time, and the money put into a fund to buy the work of living artists. The purchased works were to be given to museums across the country. Since then, the institution has purchased and donated to museums nearly nine hundred paintings, drawings, and graphic works. Fortunately, the purchase fund is now large enough that the academy–institute has been able to place a moratorium on the sale of Hassam's work, leaving a sizable collection on permanent exhibit as a tribute to the extraordinarily selfless and generous nature of this great American painter.

Virginia Dajani
Executive Director
American Academy and
Institute of Arts and Letters

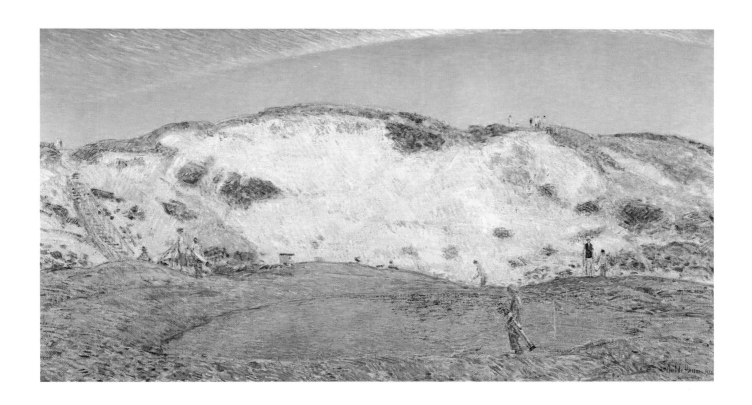

38.

R. Tait McKenzie

American (1867–1938)
Pole Vaulter, 1923, cast ca. 1923–24
Bronze, 18 in. high
Marked: R. Tait McKenzie, Fecit
1923. According to the artist's
notes, ''Nelson B. Sherrill of the
University of Pennsylvania vaulted
over a bar thirteen feet in height
May 1923; the world may yet
produce an athlete who will
soar higher by another foot.''*
University of Tennessee, Knoxville

*McKenzie could hardly have foreseen that,
today, using fiberglass poles and better landing
pits, vaulters would be soaring near twenty feet.

R. Tait McKenzie immortalized a golden age of sports in bronze. His work captured Jesse Owens, David Cecil, and Lord Burghley, as well as dozens of athletes less well-known. It established him as America's foremost sculptor of sports. Medals designed by him have been treasured by champion athletes throughout the world and many of his pieces stand as monuments to courage and effort.

McKenzie believed that the modern athlete performing the pole vault presented a series of sculptural poses delightful to the eye, yet he was keenly aware of the difficulty of supporting a vaulting figure in a piece of sculpture in the round. He found the solution when, in San Francisco, he saw a carving in jade of a seal set on a column with clouds on all four sides: ''There upon I set up a shaft on which the pole and the uprights were shown 'in relief,' the surfaces decorated along the same motif of clouds and birds to give the impression of greater height.'' McKenzie captured the natural pose of the vaulter at the precise moment he was pushing with his arms to propel his body over the bar.

Speaking about his sculptural technique during the 1924 exhibition at the Galleries Georges Petit in Paris, McKenzie said, ''Look at this vaulter. His pose is instantaneous. Yet every line, every position is correct. That is because I memorize the figure in action I catch their poses on the wing, as it were.''

Subsequent to his world's indoor record vault of thirteen feet in May 1923, Nelson Sherrill posed for the sculpture by walking around McKenzie's studio on his hands. As McKenzie wrote, ''The muscles of his arms and shoulders [were] acting almost in exactly the manner of the 'push up' in the pole vault.''

Andrew J. Kozar
Director
Joseph B. Wolffe Collection
The Sculpture of R. Tait McKenzie
University of Tennessee, Knoxville

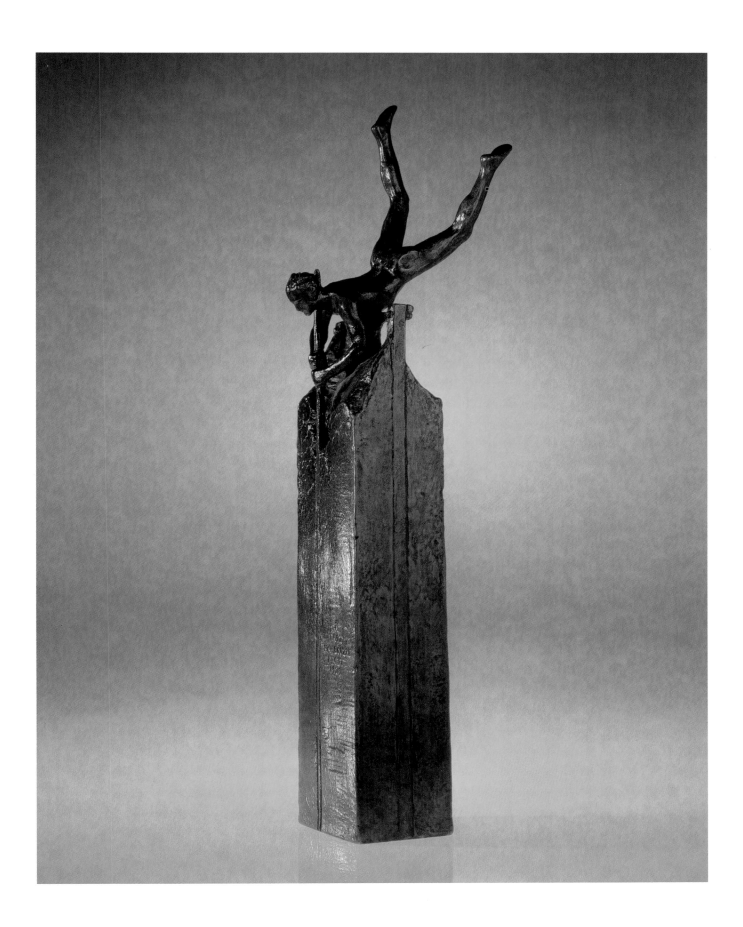

George Bellows

American (1882–1925)
Ringside Seats, 1924
Oil on canvas, 59¼ x 65⅛ in.
Signed in oil, l.r.: Geo. Bellows
Hirshhorn Museum and Sculpture
Garden, Smithsonian Institution,
Washington, D.C.
The Joseph H. Hirshhorn Bequest,
1981

Bellows was one of the most vivid and versatile painters of the American urban scene in the early part of the twentieth century. While he painted many aspects of city life, as well as portraits and seascapes, Bellows is perhaps best known for his sporting pictures which display his talents as a keen observer of human drama.

Among Bellows's most celebrated works are the six paintings and numerous drawings and prints that he made of prizefighting scenes. While three paintings from 1907 and 1908 depict boxing as the back-room sport that it was in New York at that time—relegated by law to private clubs—by 1924, when he painted *Ringside Seats* and two other major oils, boxing had become a regulated and legitimate, if still brutal, public sport. The setting of *Ringside Seats* is probably the old Madison Square Garden, the famous sports arena in New York City. Although Bellows often depicted crucial moments of heightened action in his boxing pictures, the moment he portrays in *Ringside Seats* is one of relative stillness, the pre-fight introduction of the contestants.

The largest of Bellows's boxing pictures, *Ringside Seats* is also unique in his depiction of the subject in that it is based on a drawing that does not illustrate an actual event. Bellows was commissioned by *Collier's* magazine to illustrate a short story, "Chins of the Fathers," by Jonathan Brooks. The story and drawing (which was cropped, to the artist's great dismay) were published in the May 3, 1924, issue of the magazine. Bellows completed the painting at his home in Woodstock, New York, during the same month. The painting takes its title from the passage in the story, "I've got two ringside seats, one for me and one for the girl." As in many of Bellows's fight pictures, the members of the audience in *Ringside Seats* appear at least as combative as the fighters. Here, the activity of the crowd provides an ironic foil for the stoicism of the boxer being introduced in the ring.

The muted colors in this painting skillfully convey the dark and smoky interior of the sports arena. The stable composition dictated by the inverted, asymmetric pyramid of light reflects Bellows's interest, in his late paintings, in geometric organization and theories of "dynamic symmetry." The flattened space in *Ringside Seats,* and the poses and rhythmic alignment of the figures along the foreground rope in the ring, suggest an allusion to the Parthenon friezes and reflect Bellows's interest in classical relief sculpture. Together, these formal elements serve to create a ceremonial or elegiac mood, connecting *Ringside Seats* with those paintings by Thomas Eakins in which the sporting arena is pictured as a scene of complex psychological as well as physical action.

James T. Demetrion
Director
Hirshhorn Museum
and Sculpture Garden

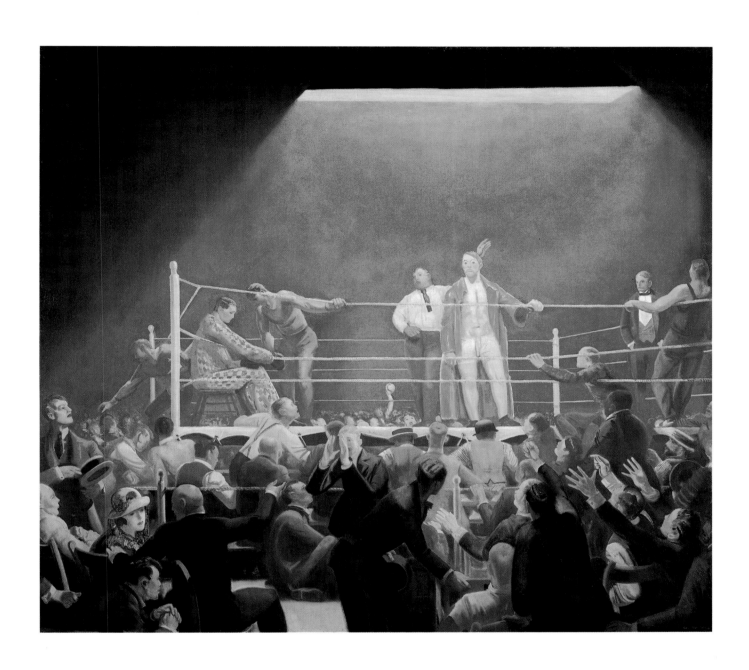

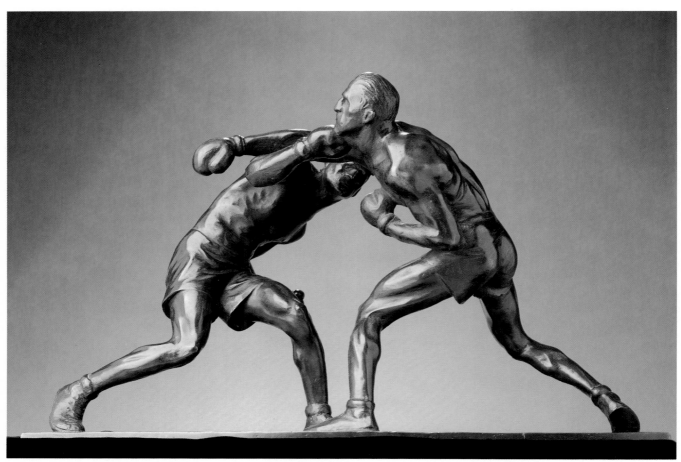

40–42.

Mahonri Mackintosh Young

American (1877–1957)

(40) *On the Button,* 1926–27
Bronze; 13⅞ in. high, base:
23¼ x 7⅜ in.
Signed on base: ''MAHONRI''
with copyright and thumb-
print; foundry mark: ''ROMAN
BRONZE WORKS, N.Y.''

Mahonri Mackintosh Young, grandson of Mormon pioneer Brigham Young, was born in the pioneer West. Though Utah was still a territory, the arts were already well-established and thriving at the time of his birth. Under the guidance in Salt Lake City of academically trained artists who had studied in Paris, Young followed his early art studies with further study at New York's Art Students League and at the Académie Julian in Paris.

Young was a versatile artist, creating paintings, prints, water-colors, drawings, and sculpture. It is his sculpture, however, that established his reputation as a principal figure in the Realist move-ment of the early 1900s. Drawing inspiration from the figures of Jean François Millet, Constantin Meunier, and the style of Rodin, Young's work was influential in establishing new directions in American sculpture. His sculptural themes include laborers and prizefighters, Native Americans of the Southwest, cowboys and pony express riders of the West, fellow artists and dignitaries, and historical events.

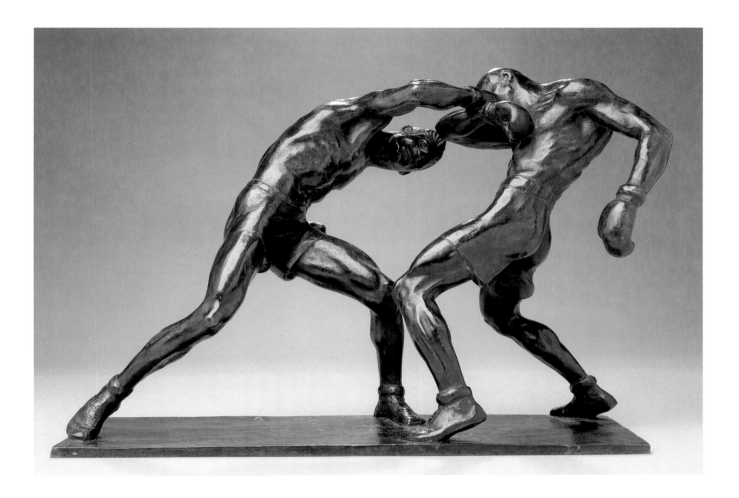

(41) *Right to the Jaw,* 1926–27
 Bronze; 13⅞ in. high, base:
 19⅛ x 7½ in.
 Signed on base: "MAHONRI
 NO 12"; foundry mark:
 "ROMAN BRONZE WORKS,
 N.Y."

Once called the George Bellows of realistic American sculpture, Young was Bellows's contemporary and friend. Bellows is often credited with inspiring Young's interest in boxers as subjects for art, but, in fact, Young's interest in the sport began early in his career. Young's interest in prizefighters appears in the many renderings of boxers in his early Paris sketchbooks of 1905. Moreover, his brother Wally, a sports writer for the *San Francisco Chronicle,* encouraged him to use his art to capture the essence of the sport of boxing, and the two often attended matches together. When Young was a student in Paris, he went to amateur boxing matches with Leo Stein. Their enthusiasm for the sport led to a friendly sparring match in which Young injured his right thumb while landing a blow to Stein's forehead. The injury forced him to stop modeling for five months, during which time he developed his skill with watercolor.

Young's boxers illustrate his technical and artistic mastery of the sculpture medium as well as his ability to capture the human

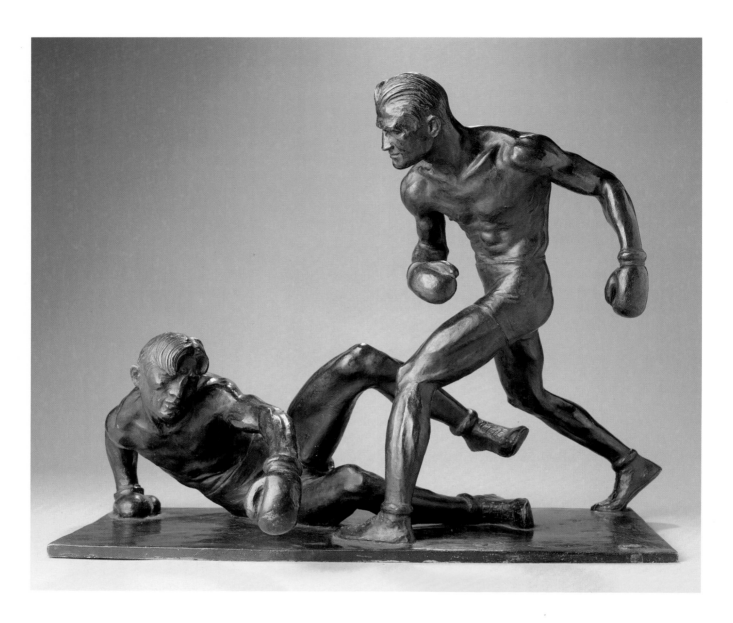

(42) *The Knockdown*, 1927
Bronze; 23 in. high, base:
28⅜ x 12 in.
Signed on base: ''No. 1
MAHONRI'' with copyright;
foundry mark: ''CIRE/A.
VALSUANI/PERDUE''

Museum of Fine Arts, Brigham
Young University, Provo, Utah
Aquired, 1959, by Brigham Young
University through purchase
and gift.

form in action. He sought to infuse the material of sculpture with
life, striving to make each work function like one of nature's own
creations. These sculptures, all created from live models of boxers,
are powerful rhythmic compositions where the pose and position
of the figures create the energy and tension found in the sport.
These sculptures, however, represent more than the fusion of
Young's artistic genius with his ability to accurately model anatomy.
They reveal also his empathy for the human struggle, where some
are winners and some suffer defeat.

Virgie D. Day
Associate Director
Museum of Fine Arts,
Brigham Young University

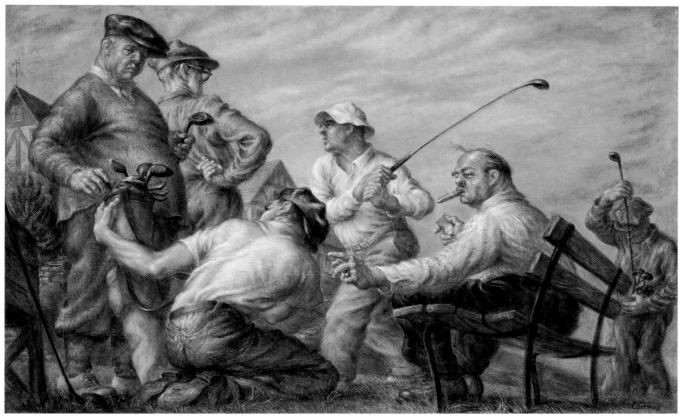

43.

Paul Cadmus

American (b. 1904)
Aspects of Suburban Life: Golf, 1936
Oil and tempera on fiberboard,
30¾ x 50 in.
National Museum of American
Art, Smithsonian Institution,
Washington, D.C.
Transfer from the U.S. Department
of State (1978.76.1)

*A*spects of Suburban Life: Golf is one of a series of four panels Paul Cadmus created that depicts the leisure pastimes of contemporary Americans. Commissioned by the Treasury Relief Art Project during the Depression as decoration for federal buildings, the paintings were an important part of the artist's first one-man exhibition in New York in 1937. *Golf* is a striking example of Cadmus's typical biting satire. Observing the foolishness and failures of American society, the artist here takes a hard look at the idle rich. The overfed golfers, smoking and posturing, pursue the game in a desultory fashion while the caddy assumes a subservient position in the composition. The artist's eye for telling details—for example, the contrast of the caddy's worn shoe soles with the seated golfer's conspicuous ring—gives the image an immediate familiarity that makes the condemnation it implies especially clear.

Elizabeth Broun
Director
National Museum of American Art,
Smithsonian Institution

44.

Richmond Barthé

American (1901–1989)
Boxer, 1942
Bronze, 16 in. high
The Metropolitan Museum of Art,
New York
Rogers Fund, 1942

According to Richmond Barthé his primary objective is to capture the spiritual element of his subjects. In *Boxer*, he takes great care to achieve a composition that is complete and exciting from all points of view, and to find the characteristic look and gesture that reveal the psychological state of his subject.

Boxer was shown in the Artists for Victory exhibition at the Metropolitan Museum in 1942, and was awarded a purchase prize of five hundred dollars. Conceived as an "expression of the desire on the part of the Museum to proclaim its faith in the American artist during one of the most critical years in our history" (The Metropolitan Museum, Artists for Victory: An Exhibition of Contemporary American Art, New York, 1942), the exhibition was notable in that it was organized by the artists themselves. They did so under the aegis of Artists for Victory, Inc., an emergency wartime agency representing the twenty-three leading art societies in New York City. The museum provided funds to cover not only the cost of the exhibition but also the purchase of prize-winning works to be added to the museum's collection.

Philippe de Montebello
Director
The Metropolitan Museum of Art

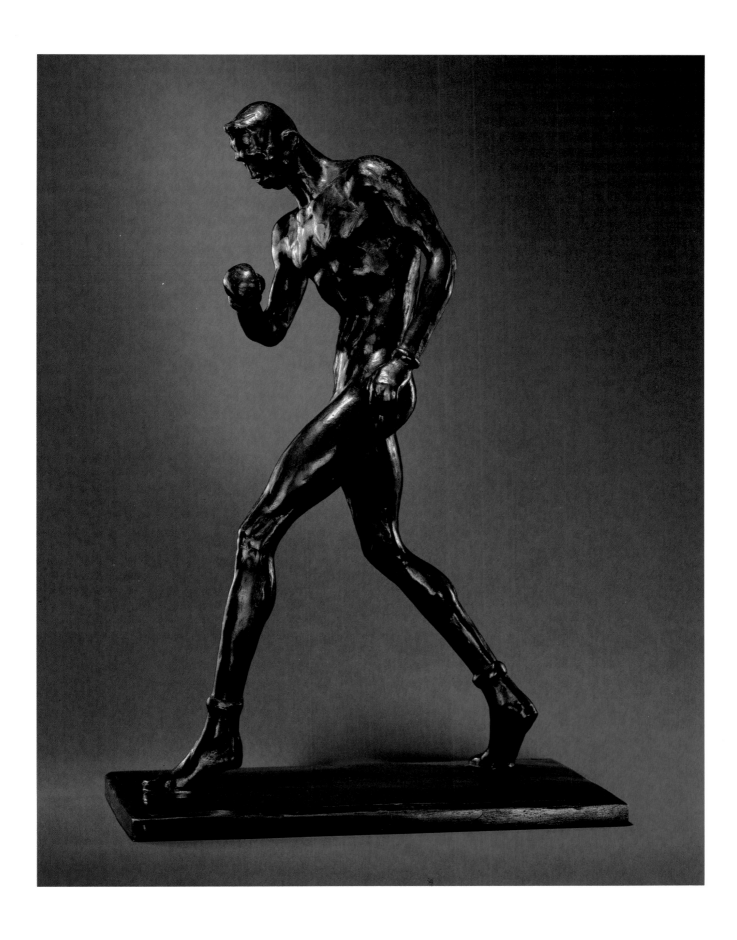

45.

Joe Brown

American (1909–1985)
Boxers, 1943
Bronze, 24 in. high
Joe Brown Foundation,
Princeton, N.J.

Joe Brown, like his teacher R. Tait McKenzie, was particularly noted for his sculpture of athletes, works which he endowed with feeling and realism. Four of his works, heroic-sized sculptures of six football and baseball players, surround Veteran's Stadium in Philadelphia.

A former professional boxer, Brown was at his best depicting athletes in the prizefighting game. *Boxers* brought recognition to Brown early in his career as a sculptor, receiving in 1944 the Helen Foster Barnett Prize at the 118th Annual Exhibition of the National Academy of Design. The noted sports writer Red Smith wrote glowingly about Brown's sculpture of athletes in a report on a 1952 exhibit at Yale University, in which he expressed a special fondness for *Boxers*.

Joe Brown served as sculptor in residence at Princeton University as well as associate professor of sculpture in the university's school of architecture. He retired in 1977, after forty years, as professor emeritus.

Tim Maslyn
Joe Brown Foundation

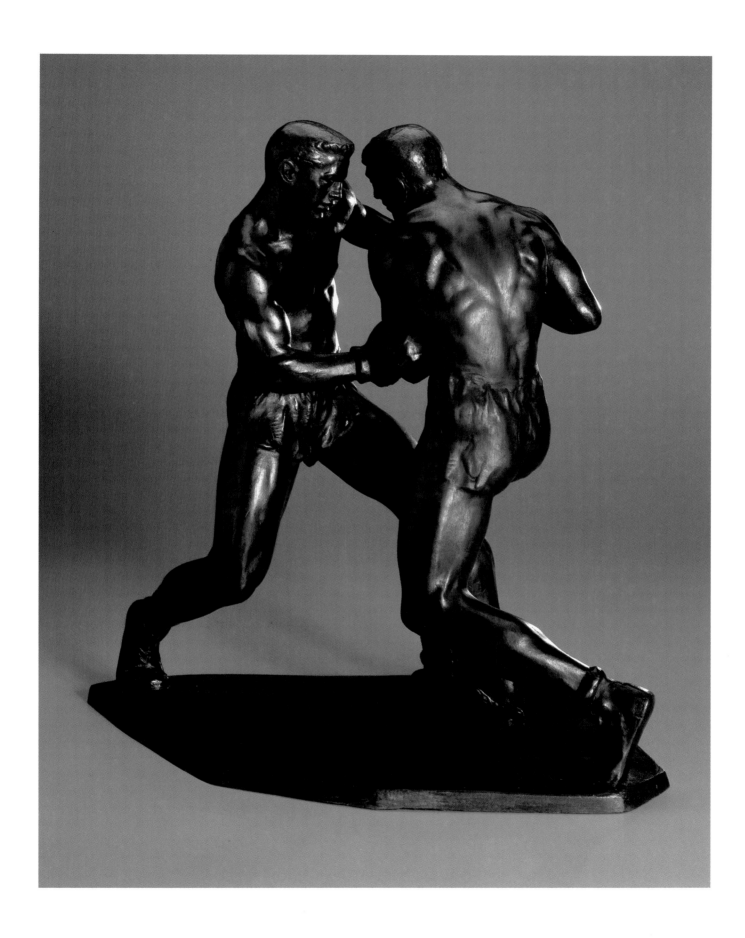

Milton Avery

American (1893–1965)
Fencers, 1944
Oil on canvas, 48¼ x 32¼ in.
Santa Barbara Museum of Art
Given in memory of Maximilian
von Romberg by Emily Hall,
Baroness von Romberg

W hether a maverick by virtue of background, destiny, or choice, Milton Avery stands out from those whose influence he absorbed, from his contemporaries and his close artist-associates, as a true individual pursuing his own vision. Seen from the vantage point of our historical perspective, his career—from the time he arrived in New York in 1925 until his last work in the early 1960s—seems a steady and undeviating progression. Avery's gradual simplification or refinement of means and vision resulted in works of great variety and complexity, subtlety, and quiet power. This relatively independent achievement is all the more remarkable when we consider that Avery worked during his early career in a mode contrary to the prevailing American Scene and Social Realist painters, assimilated elements of European modernism at a time when they were not popular, and preserved a representational basis to his art when abstraction was in ascendancy. By preserving his singular vision and not succumbing to fashion, theories, or schools, Milton Avery ultimately earned the distinction of recognition as an American master in the tradition of Albert Ryder or Thomas Eakins.

Avery's distinctive style can be considered the result of prolonged formulation and experimentation. He assimilated, more successfully than many American artists, the best lessons of the Fauves, of Matisse and Picasso, while preserving in the planning and design of his pictures his skill as a draftsman. On examination, his paintings and watercolors are structures of color and simplified forms deftly composed and balanced. The colors are luminous, usually similar in intensity and weight, and seem to almost vibrate on the surface of the picture where they create a carefully designed pattern. Within this framework of semi-abstract shapes, shallow space is suggested by diagonal planes and overlapping contoured forms, the whole held together in a finely tuned equilibrium. His choice of subject matter raised the commonplace—domestic events, landscape, figure studies, a tree or bird—to a level of monumentality and timelessness.

Fencers, a work of 1944, occupies a special place in Avery's life and oeuvre. That year he had his first one-man museum exhibition at the Phillips Memorial Gallery (now The Phillips Collection) in Washington, D.C. This was followed in January 1945 with concurrent exhibitions at the prestigious Rosenberg and Durand–Ruel Galleries in New York. Yet critical recognition was mixed and it was only under pressure that the Whitney Museum of American Art included an Avery painting in its 1944 Biennial—that painting was *Fencers*.

Among the large number of works he produced during 1944, Avery clearly achieved a degree of assurance in his handling of both form and color that marks his mature style. Its hallmarks are clearly set out in *Fencers* where the artist suggests the concentrated intensity of this sport through misleadingly simple means. The protagonists in contrasting colors are counterposed on a base of diagonal planes, their limbs a series of interlocking angles. To

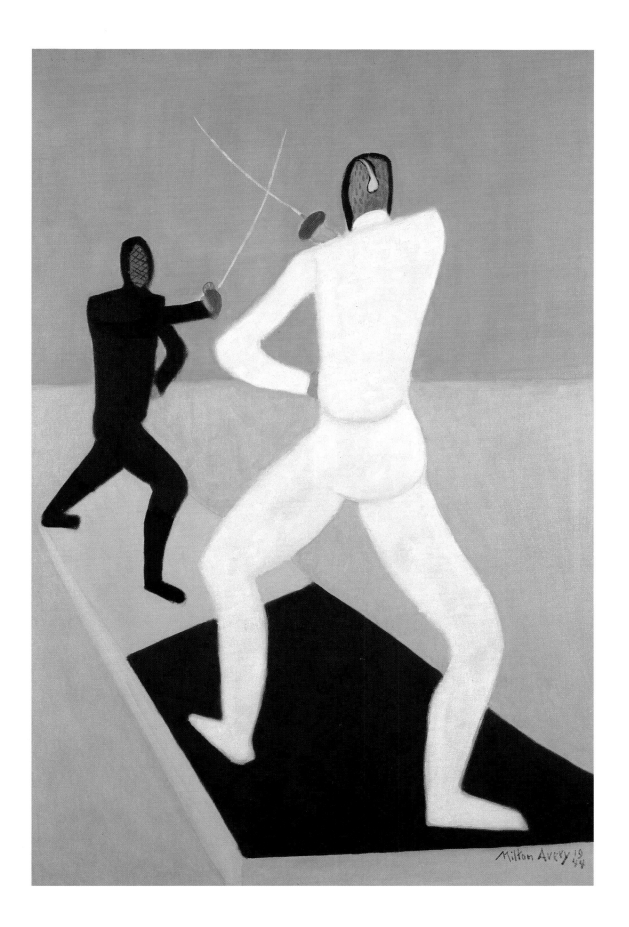

suggest their energetic interaction, each form and color is echoed in a reciprocal form, the colors reduced to a minimum. Such an active subject is rare in Avery's work and this animation is in interesting contrast to *Ping-Pong* (also of 1944) or *Card Players* of 1945, where the opponents merge and overlap in the shallow pictorial space, their activity less competitive. While also strikingly different from the paintings of lyrical beach scenes or figures in repose that were to follow it, *Fencers* shows us the artist manipulating the essentials of his art and in full control of those creative skills which allowed him to maintain a compelling tension between depiction and abstraction. We recognize now the importance of that achievement in the pursuit of his singular vision.

Robert Henning, Jr.
Assistant Director for Curatorial Services
Santa Barbara Museum of Art

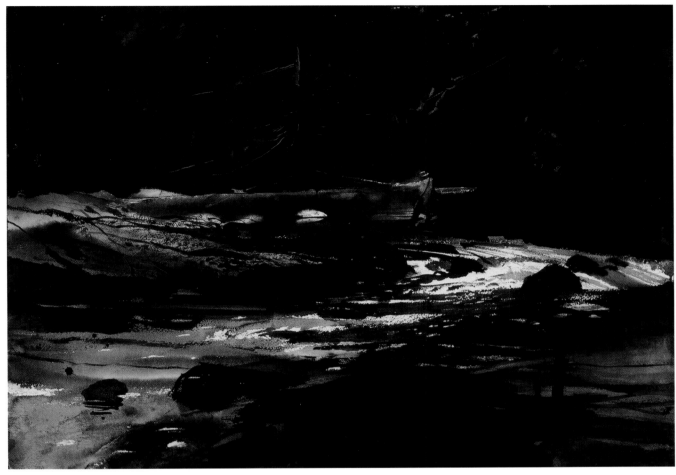

47.

Andrew Wyeth

American (b. 1917)
Trout Stream, 1948
Watercolor on rag paper, 22 x 30 in.
El Paso Museum of Art, El Paso, Tex.

Andrew Wyeth's *Trout Stream* depicts Barney Naeher, an old friend of Wyeth's family, fishing in the St. George River near Camden, Maine. This early painting is important to Wyeth's oeuvre for two reasons. It shows Wyeth's great debt to Winslow Homer, his favorite artist, and, more importantly, this watercolor expresses two familiar themes in Wyeth's work—man's relationship to nature and nature mysterious.

Leonard P. Sipiora
Director
El Paso Museum of Art

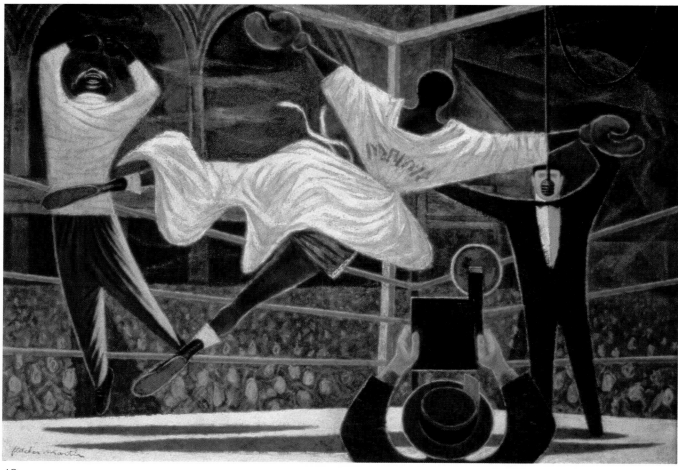

48.

Fletcher Martin

American (1904–1976)
The Glory, 1948
Oil on canvas, 36 x 48 in.
Edwin A. Ulrich Museum of Art,
Wichita State University,
Wichita, Kans.
Wichita State University
Endowment Association Art
Collection

"Nearly all of my subject material is a revived memory," Fletcher Martin, the son of a country newspaper editor, said of his work. The practically self-taught artist was born in Colorado. After joining the Navy, he moved to Los Angeles and, in 1935, the WPA Federal Arts Project gave him an opportunity to devote all of his time to painting. After finishing murals throughout the Los Angeles area, Martin taught painting at the University of Iowa and later at the Kansas City Art Institute.

In his own work, Martin—a former boxer—always strongly identified with boxing. Martin's interest was primarily in the physical aspect of the activity, not in the making of some social comment with his work. Success in the boxing ring or death in the arena represented to Martin neither victory nor defeat, but simply the end of a physical act. According to the artist, "The most commonplace subject need not be a commonplace picture."

Martin H. Bush
Director
Edwin A. Ulrich Museum of Art,
Wichita State University

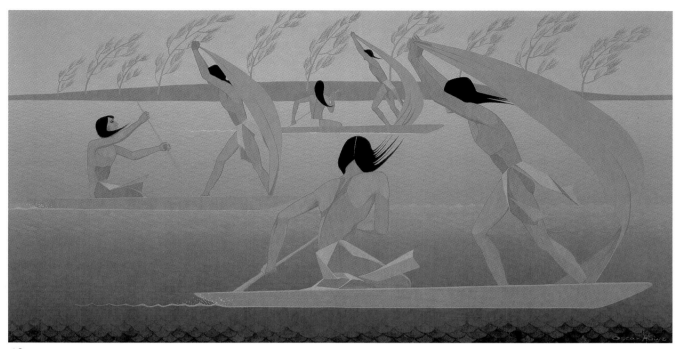

49.

Oscar Howe

American (1915–1983)
Sioux Boat Race, 1955
Tempera, 12³⁄₁₆ x 22¾ in.
Joslyn Art Museum, Omaha, Nebr.
Museum purchase fund (1955.374)

Oscar Howe's art is rooted in the traditions of Sioux and other Native American painting, but draws subtly on such modern art movements as Cubism and Futurism. Although boat racing is not something normally associated with Howe's own tribe, the Sioux, I chose this painting to emphasize the fact that sport shows itself to be a natural part of all cultures.

Graham W. J. Beal
Director
Joslyn Art Museum

50.

Marjorie Phillips

American (1894–1985)
Night Baseball, 1951
Oil on canvas, 24⅛ x 36⅛ in.
The Phillips Collection,
Washington, D.C.

My mother Marjorie Phillips, a fine and dedicated artist best known for her lyrical landscape, still-life, and figure paintings, was not herself a baseball fan and, to the best of my memory, did not even know the rules of the game. But as my father's loyal companion, she must have attended well over a hundred games during the 1930s and 1940s at Washington's old Griffith Stadium, where we had a box just behind the home-team dugout at first base. But as she explains in the following excerpt from the book *Marjorie Phillips and Her Paintings* (1985), she became intrigued with the visual aspects of the game and put her time to good use:

> It is a delight for me to write about *Night Baseball* as I had such fun and interest painting it. Of course the central interest is Joe DiMaggio as he waits for the ball about to be pitched. His elegant superanimated stance has great style. I always loved that group of three: the squatting catcher just behind the man at bat and, standing behind him, the eagerly watching umpire leaning forward with responsibility of decision.

> Duncan Phillips was a great baseball fan. I always went with him to baseball games and found that I enjoyed them more and more. I had not known the game before we were married. I would always make some pencil drawings of the grandstands, the dugout with players waiting, the plan of the baseball diamond, etc. I noted the color in the seated crowds at Griffith Stadium where the games were held at that time. One year we won the pennant and the city went wild.

> This final version of all my studies must have seemed authentic because years later when I loaned this painting for exhibition at the Palace of the Legion of Honor in San Francisco a man from Wildenstein's in New York City wanted to buy it for the Baseball Hall of Fame in Cooperstown, New York. I said I could not sell it as I had given it to my husband.

Art historian Eleanor Green has written that *Night Baseball* ''is alive with latent energy, yet classically static in balance. The overall cool palette and crisp drawing lend an objectivity to the recording of an instant that precedes frenzied activity and an emotional outburst. . . . It is one of the most popular works in the Collection, sought out both for its documentary and aesthetic appeal.''

Laughlin Phillips
Director
The Phillips Collection

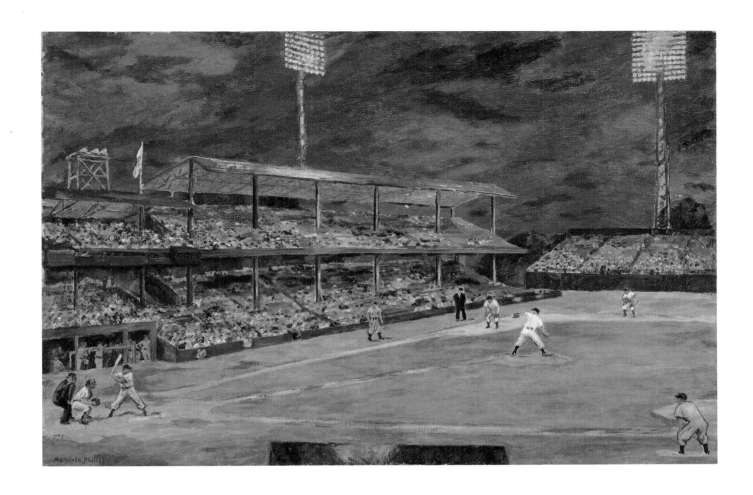

51.

Nicholas de Staël

French, born in Russia
(1914–1955)
The Football Players, 1952
Oil on canvas, 32 x 25½ in.
Modern Art Museum of Fort Worth
Gift of Mr. and Mrs. William M.
Fuller

Nicholas de Staël painted *The Football Players* in 1952, the year after he attended an evening match between France and Sweden at the Parc des Princes in Paris. An avid fan of the sport, de Staël had viewed the floodlit game with tremendous fascination. Impressed by the flashes of color, light, and movement, he dedicated most of the following year to creating paintings based on the game. Also sometimes called *The Soccer Players*, this painting belongs to that series.

De Staël's intense involvement with the immediate and physical quality of painting is apparent in *The Football Players*. He placed large blocks of primary colors on the canvas with thick impasto, so that the viewer is instantly confronted with bold shapes of blues, reds, yellows, and whites that suggest the action of the game with their aggressive application. The black background of the night sky was painted quickly and simplistically, to simulate the artificial light of the stadium. De Staël successfully conveys the motion and excitement of the game; likewise, he captures the stark contrast between the brilliantly illuminated figures and the muted colors of the playing field and sky.

De Staël, like his paintings, had a strong physical presence. A rugged, powerful man, he was an athlete, excelling in swimming and fencing. Such sports required that he make quick decisions, a habit he perhaps utilized in his painting style. He worked swiftly, completing many paintings during a short period. De Staël's time as an artist also proved to be short, as he died just nine years after his highly respected career began.

De Staël painted *The Football Players* series three years before his death. He worked prior to that time in a highly abstract manner, but with this group of pictures, turned more toward the figure. Indeed, throughout his career, de Staël struggled with the ideas of abstraction and figuration and, during the last year of his life, he turned away from the intensity of *The Football Players* and began instead to paint landscapes in a thinner, smoother, less urgent manner. *The Football Players* thus marks a crucial point in de Staël's oeuvre. Its energy and immediacy are unique to that series, and its more literal depiction of the football match illustrates the artist's transition from abstraction to figuration.

E. A. Carmean, Jr.
Director
Modern Art Museum of Fort Worth

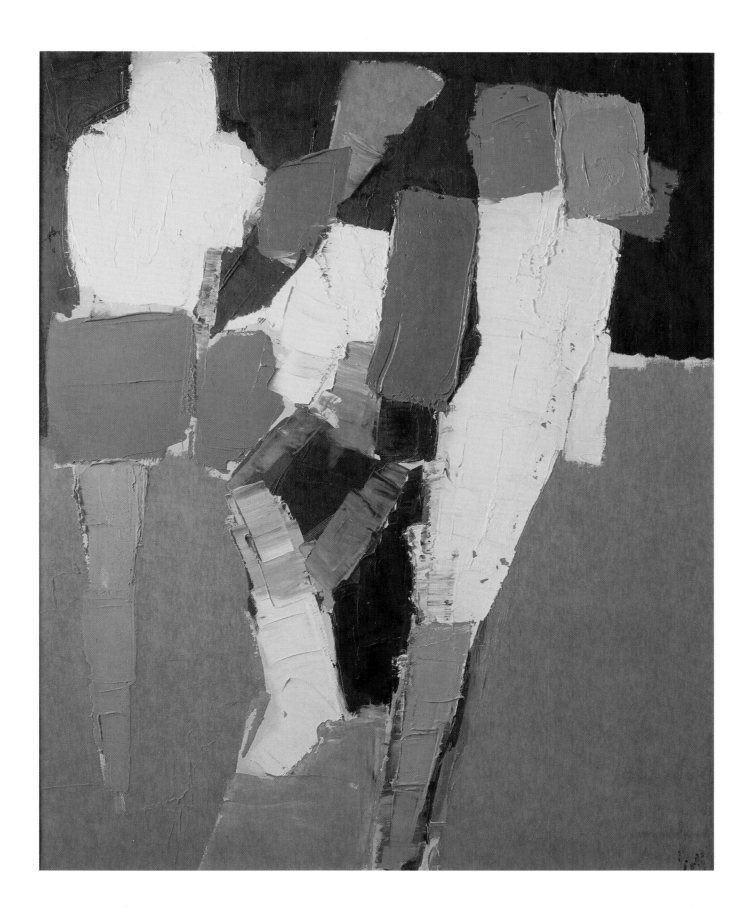

Elaine de Kooning

American (b. 1920)
Scrimmage, 1953
Oil on canvas, 24⅛ x 36 in.
Albright-Knox Art Gallery,
Buffalo, N.Y.
Gift of Mr. and Mrs. David K.
Anderson to The Martha Jackson
Collection (1974:8.16)

*S*crimmage is one of Elaine de Kooning's earliest works in the figural style that she began to explore in 1949 and that has occupied her since. Although she devoted herself almost exclusively to abstraction during the 1930s and early 1940s, she, like her husband, Willem, and Arshile Gorky, saw no reason to reject figurative art or realistic styles. As she later observed, the goal of the artist was to establish a personal style that would become evident whether he or she worked in abstract or realistic modes (Irving Sandler, *The New York School: The Painters and Sculptors of the Fifties* [New York: Harper & Row, 1978], pp. 96–97).

In *Scrimmage* de Kooning addresses a traditional compositional problem in the grouping and relation of figures. At the right she has placed a large and compact group of struggling figures, dominated by the central figure who lunges forward and whose outstretched limbs form powerfully thrusting diagonal movements. At the left a much smaller unit of two figures appears to pull back from the central group. The work thus presents a kind of dynamic asymmetry in which the major grouping of figures sets up a lateral tension across the surface of the canvas. De Kooning unifies the composition by directional brushwork and also by counterposing diagonal elements in an overall *X* pattern.

De Kooning favored such subjects as basketball, soccer, and rugby during the 1950s. One critic observed that de Kooning ''reveals the cultural meaning that sports have in the moral dynamics of our society'' (H[ubert] C[rehan], ''Elaine de Kooning,'' *AD*, vol. 28, no. 14, Apr. 15, 1954, p. 23). It is most likely, however, that de Kooning painted *Scrimmage* not as a moral critique but simply to portray a variety of active, differently posed figures, a subject that would appeal to a painter whose style is quick and vigorous. As if to emphasize these more purely formal considerations, de Kooning has omitted the facial features of her subjects and placed them in an unidentifiable environment, retaining essentials of their pose and action but eliminating all anecdotal detail. She has also restricted her color to somber tones of olive and brown, as if to underscore the formal seriousness of the work.

Douglas G. Schultz
Director
Albright-Knox Art Gallery

Reprinted from *Albright-Knox Art Gallery, The Painting and Sculpture Collection: Acquisitions since 1972* (New York: Hudson Hills Press in association with Albright-Knox Art Gallery, 1987)

53.

Alex Colville

Canadian (b. 1920)
Skater, 1964
Synthetic polymer paint on
composition board, 44½ x 27½ in.
The Museum of Modern Art,
New York
Gift of R. H. Donnelly Erdman
(by exchange)

At once tranquil and highly dramatic, *Skater* is an image whose impact is immediate. From the radically foreshortened right leg and body of the female figure to the perspectively crisscrossing traces on the ice, everything in the composition conspires to express disciplined speed. The skater is depicted from the back, resolutely gliding away from the picture plane towards a glacier-like bank of snow. The unusual pose instantly engages the viewer, whose imagination accompanies her across the ice. Alex Colville uses the activity of skating in a bare, winter landscape in a manner close to literary, as a metaphor for human life in the objective world. ''The *Skater*,'' he has explained, ''is about being. It is about controlled but relaxed conscious movement in a kind of elemental, void-like aspect of nature—a kind of environment which I think many people find frightening. However, the Skater is not frightened.''

Much of the power of *Skater* derives from the precision and care of its construction. Painted in acrylic, it presents a smooth, sealed surface; no trace of the hand of the artist intervenes between subject and viewer. The harmonious, almost sleight-of-hand way in which all the elements of the picture relate to each other comes from the complicated and painstaking process of applying the golden section, a proportion used by artists for centuries in composing pictures. The solid form of the skater's body is in exquisite equilibrium with the landscape. Only the blade on her raised foot departs from the general pattern. Almost appearing to project beyond the picture plane, it intensifies the sense of swift movement.

Alex Colville was born in 1920 in Toronto and has spent the greater part of his life in Nova Scotia. During World War II he served with the Canadian army as an artist. He taught at Mount Allison University in Sackville, New Brunswick, from 1946 to 1963, when he resigned to devote himself full-time to painting. Less well-known in the United States than Canada, Colville has often been described as a Magic Realist although fantastic subject matter is virtually absent from his work.

Richard E. Oldenburg
Director
The Museum of Modern Art

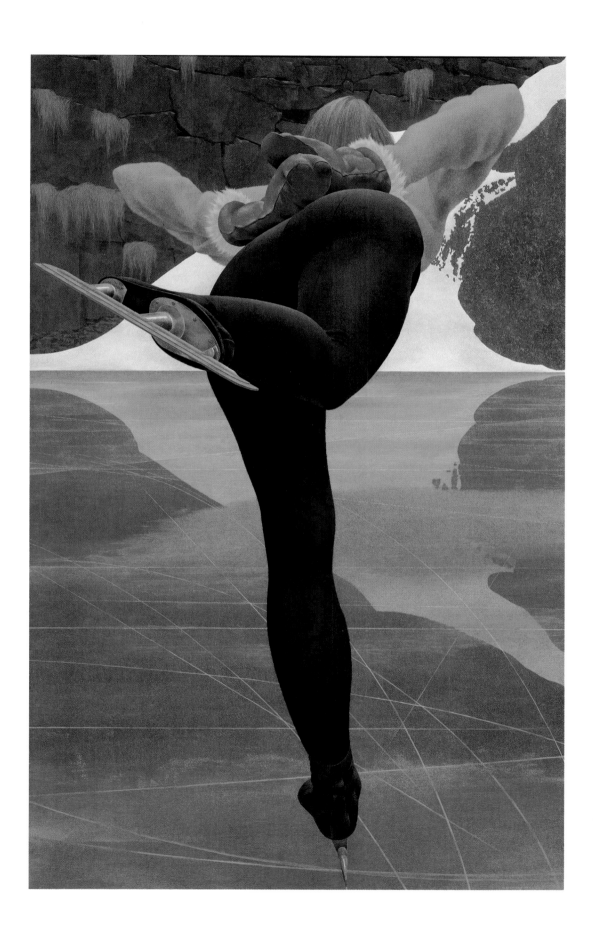

54.

Rhoda Sherbell

American (b. 1938)
Charles Dillon (Casey) Stengel,
cast in 1981 from a 1965 plaster
Polychromed bronze, 44 in. high
National Portrait Gallery,
Smithsonian Institution,
Washington, D.C.
Museum purchase

I am charmed by this portrait every time I pass it in our halls, and I well understand why it is one of the favorites of visitors to the National Portrait Gallery.

If baseball is the quintessential American sport, Casey Stengel is surely one of the quintessential characters of the game. He learned the tactics of the diamond as a player, but concealed his intellectual and intuitive talents beneath a comic façade. His skill as a leader only emerged when he left the playing field to become a manager in 1926 and, after a string of less-than-inspiring jobs, led the New York Yankees to ten pennants and seven world championships.

Portraiture at its best involves much more than merely grasping the arrangement of a subject's features. In her delightfully lively, full-length sculpture, Rhoda Sherbell has captured Stengel at his most alert and combative, the essence of the hands-on manager. Stengel was never the fashion plate, and Sherbell has rendered him in all his rumpled intensity, eagle eye scanning the field for the next play to call or to spot the incident that will inspire one of his famous neologisms.

Alan Fern
Director
National Portrait Gallery,
Smithsonian Institution

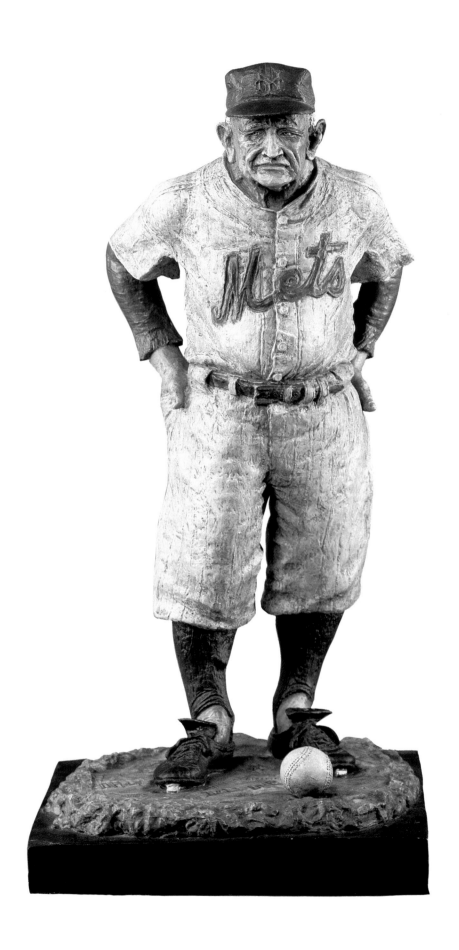

55.

John De Andrea

American (b. 1941)
Boys Playing Soccer, 1971
Polyester and fiberglass resin with
polychrome in oil, 60 in. high
Everson Museum of Art,
Syracuse, N.Y.
Gift of Mrs. Robert C. Hosmer, 1972

*B*oys Playing Soccer (or *The Soccer Players,* as it has become familiarly known at the Everson) is one of the Everson Museum of Art's most poignant and popular works of art. In a medium-sized collection that specializes in American art from the eighteenth century to the present, this is the museum's prime example of hyper- or super-realism, an early seventies antidote to Abstract Expressionism and an outgrowth of Pop Art.

The Everson's acquisition in 1972 of *Boys Playing Soccer,* shortly after it was created by John De Andrea, was attended with considerable controversy in Syracuse. Some local politicians thought the work pornographic and threatened the Museum's funding. Fortunately, more reasonable judgments prevailed, recognizing that the early critics' embarrassment did not reflect any prurient quality inherent in the sculpture.

De Andrea looks for beauty on the surface of figures and often juxtaposes nude figures in studied relationships to one another. His figures often startle, or even shock, with their exquisite lifelikeness. The figures in *Boys Playing Soccer* are lost in action, transfixed by their game and their keen attention on the white ball in their midst. Innocence and rapt involvement are expressed on their faces, and a delicacy of movement informs their active poses. While it has been often said by critics of the piece that it is unlikely two boys would be playing soccer without their clothes on, the work was in fact inspired by a photograph in *National Geographic* of Indonesian boys playing soccer in the rain completely nude. The poses in the photo are similar to, but not exactly duplicated in the sculpture. The actual sculpture was life-cast from two African-American boys, and the precariously balanced polychromed polyester-resin fiberglass work is painted with the greatest refinement and verisimilitude.

There is a classic beauty sought here in the trim and attractive figures and in the controlled balance of their pose. As a contemporary tour de force in art making with materials unknown to the Greeks, *Boys Playing Soccer* might be compared to such ancient figurative sculptures of athletic action as Myron's *Discus Thrower.* Another kind of ideal—one coming out of modern American reality—informs De Andrea's naturalistic work. Nonetheless, the choice of image and the phenomenal control of the mediums used present us with a riveting work of surprisingly tender feeling.

As to the differences of individual taste, *Boys Playing Soccer* is exemplary in its ability to command a response, on its artistic merits or on the appropriateness of its subject matter. It still remains for me—after twenty years and the all-but-forgotten notoriety at its first unveiling—one of the most provocative and arresting works in the Everson's collection and an eloquent testimony to the very elemental and innocent joy of sport.

Ronald A. Kuchta
Director
Everson Museum of Art

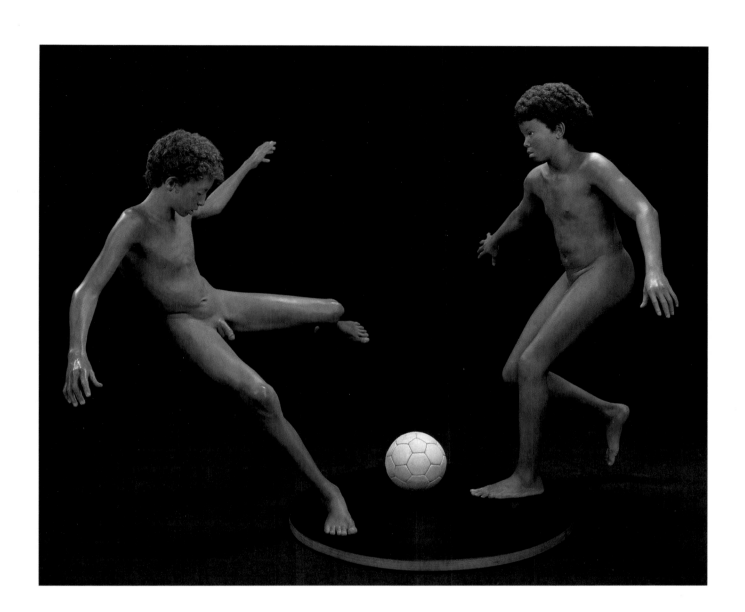

56.

Armand Arman

French (b. 1928)
Untitled, 1972–73
Plexiglas, resin, and football
helmets, 50 x 50 x 6 in.
La Jolla Museum of Contemporary
Art, La Jolla, Calif.
Gift of *Sports Illustrated*

*U**ntitled* consists of severed football helmets set in Plexiglas with resin. Crafted by the French artist Armand Arman, this sculpture is a witty look at the danger and artifice of that all-American sport, football. A helmet—a piece of equipment both personal and impersonal—serves as the border between individual and team, between safety and danger. By severing the protection device and adhering it to a clear hard surface in multiples, the artist deconstructs not only the protective myth that surrounds the football ''hero,'' but especially the role the audience plays as distant and trusting worshipper. *Untitled* is a seminal work in the La Jolla Museum of Contemporary Art's collection, as it speaks of a unique insight into American life and culture that perhaps only a foreigner's perspective can engender.

Hugh M. Davies
Director
La Jolla Museum
of Contemporary Art

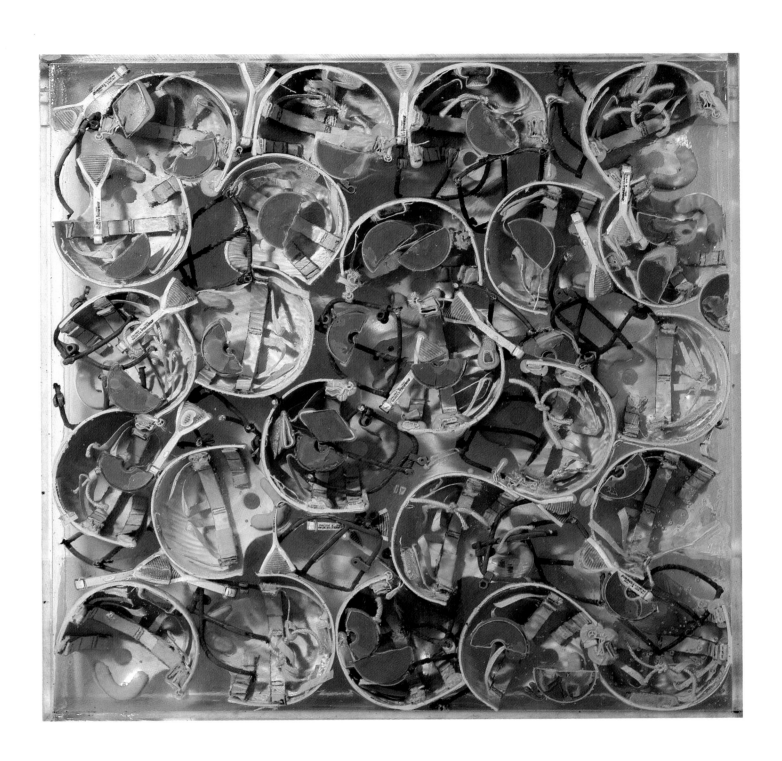

57–66.

Andy Warhol

American (1928–1987)
Athletes (series of ten), 1978

(57) *Muhammad Ali*
(58) *Chris Evert*
(59) *Bill Shoemaker*
(60) *Rod Gilbert*
(61) *Jack Nicklaus*
(62) *Pele*
(63) *Tom Seaver*
(64) *Kareem Abdul Jabar*
(65) *O. J. Simpson*
(66) *Dorothy Hamill*

Synthetic polymer and silkscreen
on canvas, each 40 x 40 in.
Wight Art Gallery, University
of California at Los Angeles
Gift of Frederick Weisman Company

*A**thletes*, a set of portraits by Andy Warhol, was given to the Wight Art Gallery at the University of California at Los Angeles (UCLA) by Frederick Weisman in 1982. They are considered an important and representative group of paintings by Warhol, particularly because they expose the contemporary reality of a much-honored form of activity in the United States—athletics. Warhol was intrigued by the notion of celebrity, and the media and technology that created it. From the artist's perspective, the fact that athletics has become big business and athletes have become media stars and entrepreneurs changes these individuals from sports heroes to national box-office commodities.

Warhol used the most familiar and popularized photographic images of famous individuals for his artworks. At UCLA, this has led to the kind of controversy that would have delighted Warhol, the debate centering not on the artistic merit or meaning of *Athletes* but on which athletic celebrities are portrayed and the loyalties their images engender. Appropriately displayed in the lobby of a sports facility on the UCLA campus, the series includes famous athletes who happen to have attended a local rival university, which in itself has caused considerable protest. The portraits in these paintings are so familiar and recognizable that they arouse the strong reactions of university alumni, tempting them to overlook aesthetic or broader cultural considerations, and that is exactly the phenomenon that Warhol was exposing and exploiting. We are forced to question these objects that he created. Are they detached works of art to hang in a museum, dynamic symbols of athletic excellence, or have they become like corporate logos, giving rise to a kind of "brand" loyalty?

When I met Warhol in 1982 and asked him how he felt about *Athletes* going to an educational institution, he seemed pleased but unsure of how the series would be received in an academic environment. He made a career of understanding how context could change a media image into a work of art, and how his works of art were particularly susceptible to change based on their location and environment. Choosing this series to travel to several locations in a new context of sports images is a way of continuing his work, of exposing contemporary reality as well as testing the current validity of his ideas.

Edith A. Tonelli
Director
Wight Art Gallery,
University of California
at Los Angeles

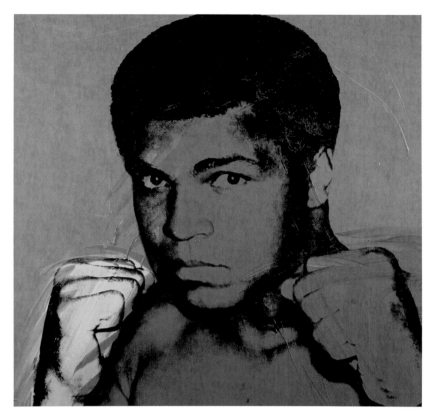

57.

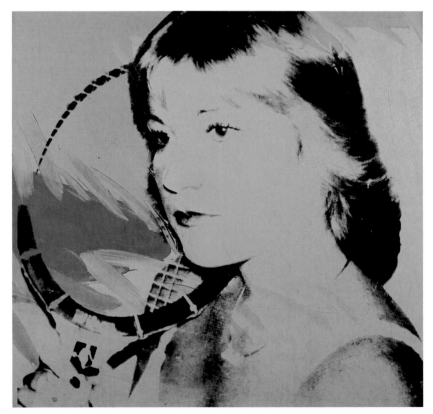

58.

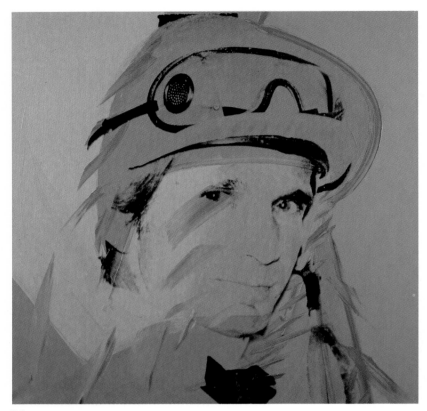

59.

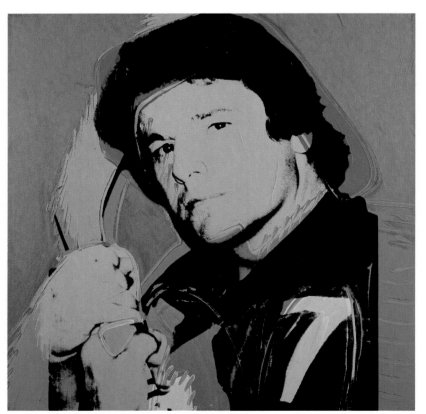

60.

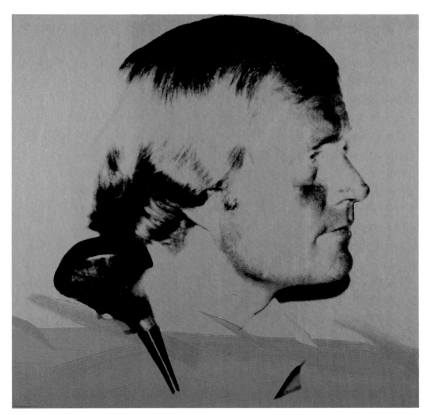

61.

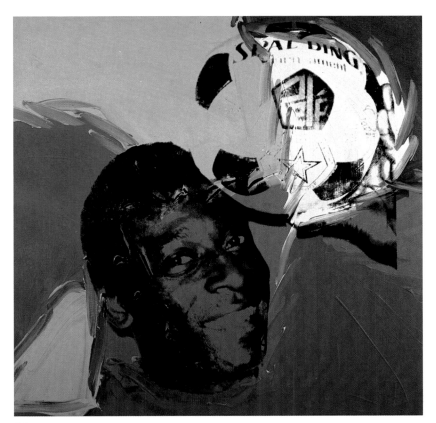

62.

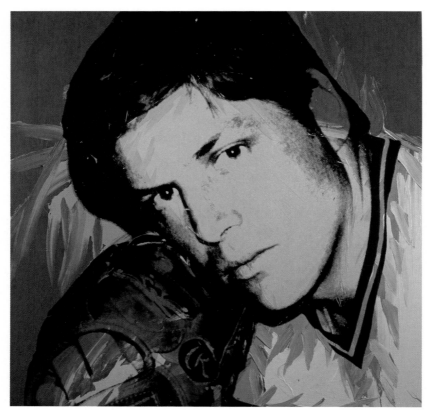

63.

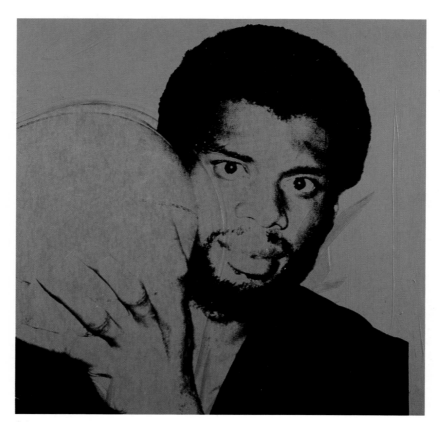

64.

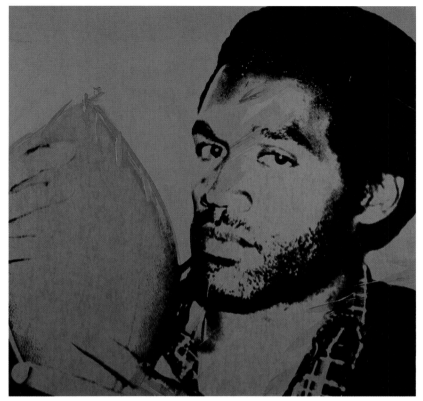

65.

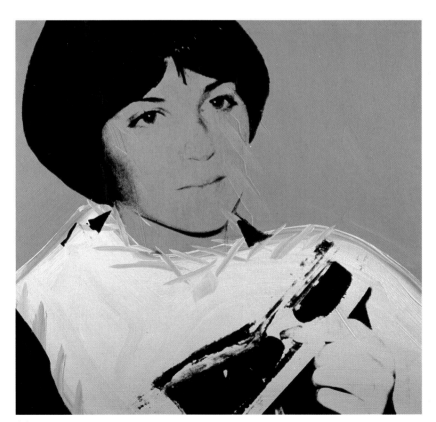

66.

67.

Red Grooms

American (b. 1937)
Fran Tarkenton, 1979
Painted vinyl, aluminum armature,
with polyester stuffing, 96 x 56 in.
The Butler Institute of American
Art, Youngstown, Ohio

A generation of artists was drawn to the spirited, irreverent, and highly commercial character of the Pop Art movement of the 1960s, but only one seems to have retained the true character of that idiom. It is Red Grooms whose work continues to echo the American popular culture in lighthearted, fanciful pieces which, like the wild fantasy of the Sunday comics, never seem to wear thin. The subject matter that sets his colossal imagination into motion is our culture, the most complex and heterogeneous one in the world.

Born in 1937 in Nashville, Tennessee, Red Grooms first came to national prominence as a pioneer of the "happening"—those dramatic conceptualizations that helped define the Pop era. In many ways the theatrical character of those early works remain and continues to reveal itself in the constructed environments with which Grooms became identified in the 1970s. In such installations as *Discount Store, Banquet For Henri Rousseau, Ruckus Manhattan*, and *City of Chicago*, brilliantly painted cut-out figures inhabit crowded environments of clashing painterly forms. While the large-scale installations have received much attention, Grooms has in recent years produced a body of editioned pieces that rank among the most significant of their kind in postwar America. From cast metal to cast paper, these serial works have become icons of a culture that seems to place Monday-night football above any other activity or that makes Bo Jackson's face more recognizable or revered than those of even our greatest artists.

In many ways Grooms has been a major player in the redefinition of American editioned art. *Fran Tarkenton*, created in a limited edition of eight plus artists proofs, represented a primary breakthrough in materials usage and fabrication. A contemporary American idol is presented as if appearing on "Laugh-In" (Pop Art's television-show counterpart of the sixties). While Jacques Louis David subtly questioned Napoleon's machismo two centuries ago, Grooms chooses to create a "schtick" right out of vaudeville, as the greatest quarterback of his time tiptoes through a flower patch in search of a receiver. Helmetless and sporting a yearbook smile, this Viking Hall of Famer looks more intent on impressing the New York City Ballet than the New York Jets. Grooms is Thomas Nast, Will Rogers, and Claes Oldenburg rolled into one, giving American pictorial art that sense of humor and humanity which has been missing in much American art since Andy Warhol's Factory.

Louis A. Zona
Executive Director
The Butler Institute
of American Art

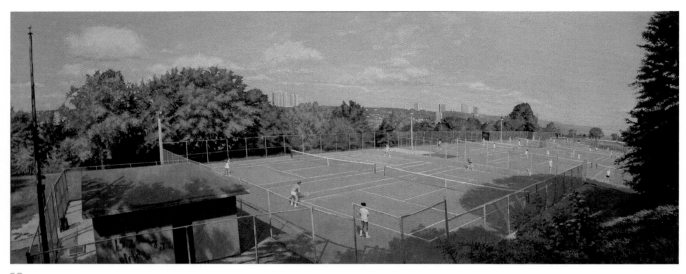

68.

Rackstraw Downes

American, born in England (b. 1939)
The Tennis Courts in Riverside Park at 119th Street, 1978–80
Oil on canvas, 18¾ x 46¼ in.
Whitney Museum of American Art, New York
Purchase with funds from the Louise and Bessie Adler Foundation, Inc., Seymour M. Klein, President (81.2)

This painting depicts public tennis courts in Riverside Park, on the Upper West Side of Manhattan. These courts, well-known by residents and by students and faculty of nearby Columbia University, are always much in demand and require players to reserve courts days in advance.

Rackstraw Downes, born in Pembury, Kent, England, and educated at Cambridge and Yale Universities, portrays sites near his apartment in New York City and his house in Morrill, Maine. An avid tennis player who uses the courts at Riverside Park himself, Downes executed this painting *en plein air* from an elevated viewpoint. While the curve of the horizon line mimics a camera's wide-angle lens, Downes's interest is not in suggesting an affinity with photography, but in revitalizing representational painting with directness and clarity to express personal, yet detached involvement.

Downes exhibited widely throughout the 1970s and 1980s, and contributed to the renewed interest in realism in contemporary American art. His works address the issue of representation within modernist painting, while recalling the technical achievements of seventeenth-century Dutch topographical views and nineteenth-century Barbizon painters' rendering of light. Downes looks to these landscape precedents for formal possibilities rather than for associative elements such as the sublime, nostalgia, or sentiment. Downes's paintings reflect their own time and place. The human presence in the urban landscape, seen in the activity of tennis players against the distant high-rise buildings, remains essential to Downes's vision of the modern world.

Jennifer Russell
Acting Director
Whitney Museum
of American Art

Index of Artists

by catalogue number

Lenders To The Exhibition

by catalogue number

Addison Gallery of American
Art, Phillips Academy
Andover, Mass., no. 3

Albright-Knox Art Gallery
Buffalo, N.Y., no. 52

American Academy and Institute
of Arts and Letters
New York, N.Y., no. 37

Charles W. Bowers Museum
Santa Ana, Calif., no. 4

Brigham Young University,
Museum of Fine Arts
Provo, Utah, nos. 40–42

Joe Brown Foundation
Princeton, N.J., no. 45

The Butler Institute of
American Art
Youngstown, Ohio, no. 67

Columbus Museum of Art
Columbus, Ohio, no. 29

The Corcoran Gallery of Art
Washington, D.C., no. 17

Dayton Art Institute
Dayton, Ohio, no. 33

Delaware Art Museum
Wilmington, Del., no. 5

The Detroit Institute of Arts
Detroit, Mich., no. 16

El Paso Museum of Art
El Paso, Tex., no. 47

Everson Museum of Art
Syracuse, N.Y., no. 55

Thomas Gilcrease Institute of
American History and Art
Tulsa, Okla., no. 10

Solomon R. Guggenheim Museum
New York, N.Y., no. 30

High Museum of Art
Atlanta, Ga., no. 9

Hirshhorn Museum and Sculpture
Garden, Smithsonian Institution
Washington, D.C., no. 39

Indianapolis Museum of Art
Indianapolis, Ind., no. 6

Joslyn Art Museum
Omaha, Nebr., no. 49

La Jolla Museum of
Contemporary Art
La Jolla, Calif., no. 56

Los Angeles County Museum
of Art
Los Angeles, Calif., no. 28

The Metropolitan Museum of Art
New York, N.Y., no. 44

Milwaukee Art Museum
Milwaukee, Wis., no. 34

Modern Art Museum of
Fort Worth
Fort Worth, Tex., no. 51

Montclair Art Museum
Montclair, N.J., no. 35

Munson-Williams-Proctor
Institute Museum of Art
Utica, N.Y., no. 7

Museo de Arte de Ponce
Ponce, P.R., no. 26

Museum of the City of New York
New York, N.Y., no. 22

Museum of Fine Arts, Boston
Boston, Mass., no. 13

The Museum of Modern Art
New York, N.Y., no. 53

National Gallery of Art
Washington, D.C., no. 36

National Museum of American
 Art, Smithsonian Institution
Washington, D.C., no. 43

National Portrait Gallery,
 Smithsonian Institution
Washington, D.C., no. 54

The New-York Historical Society
New York, N.Y., no. 24

Peabody Museum of Salem
Salem, Mass., no. 12

The Pennsylvania Academy of
 the Fine Arts
Philadelphia, Pa., no. 31

Philadelphia Museum of Art
Philadelphia, Pa., no. 15

The Phillips Collection
Washington, D.C., no. 50

Phoenix Art Museum
Phoenix, Ariz., no. 2

Portland Museum of Art
Portland, Maine, nos. 18–21

San Diego Museum of Art
San Diego, Calif., no. 23

Santa Barbara Museum of Art
Santa Barbara, Calif., no. 46

Terra Museum of American Art
Chicago, Ill., no. 14

Edwin A. Ulrich Museum of Art,
 Wichita State University
Wichita, Kans., no. 48

University of Pennsylvania
 Collection of Art
Philadelphia, Pa., no. 32

University of Tennessee
Knoxville, Tenn., no. 38

Virginia Museum of Fine Arts
Richmond, Va., no. 11

Whitney Museum of American Art
New York, N.Y., no. 68

Wichita Art Museum
Wichita, Kans., no. 27

Wight Art Gallery, University of
 California at Los Angeles
Los Angeles, Calif., nos. 57–66

Yale Center for British Art
New Haven, Conn., no. 8

Yale University Art Gallery
New Haven, Conn., no. 25

Photo Credits

Photographs of works of art seen here have been provided in most cases by the owners or custodians of the works as cited in the captions. The following list applies to photographs for which an additional acknowledgment is due.

Peter Accettola, pp. 57, 83; Will Brown, p. 49; Joseph Levy, courtesy Albany Institute of History and Art, Albany, N.Y., p. 61; David Valdez, The White House, p. 6; Graydon Wood, p. 74